D1101960

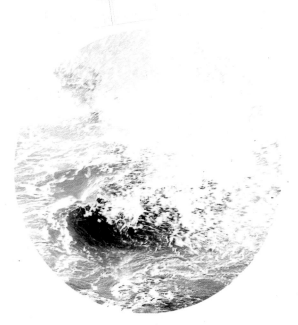

pocketbooks[13]

pocketbooks

Unravelling the Ripple

Unravelling the Ripple

by Helen Douglas

pocketbooks
Morning Star Publications
Polygon
Weproductions
An Tuireann

2001

Published by:
pocketbooks
Canongate Venture (5), New Street, Edinburgh, EH8 8BH.

Morning Star Publications
Canongate Venture (5), New Street, Edinburgh, EH8 8BH.

Polygon
22 George Square, Edinburgh, EH8 9LF.

Weproductions
Deuchar Mill, Yarrow, Selkirkshire, TD7 5LA.

An Tuireann
Struan Road, Portree, Isle of Skye, IV51 GEG.

Typeset in Minion and Univers.
Artworking and design by Helen Douglas; typesetting by Cluny Sheeler.
Design concept by Lucy Richards with Alec Finlay.
Printed and bound by Scotprint, Haddington, East Lothian.

Published with the assistance of grants from the Scottish Arts Council National
Lottery Fund and the Highlands and Islands Enterprise (HI Arts),

A CIP record is available from the British Library.

ISBN 0 7486 6303 7

List of Contents

Editor's Acknowledgements

Helen Douglas and Telfer Stokes influenced the original concept of pocketbooks through their artistic response to the book form and their commitment to publishing as an art practice. Helen's recent books, *Between the Two* and *Wild Wood*, are sensuous explorations of the landscape of her home in Yarrow; here she leaves the woods for the seas, and the Isle of Muck. Her gaze, looking West over the Atlantic, is met by Rebecca Solnit's reflections, looking West across the Pacific. Rebecca's essay is part of the journey rather than the point of departure or arrival. The richness of its reading is so rhythmic and immediate that *Unravelling the Ripple* transcends existing specialist categorisations – artist book, visual book, and so on.

I would like to thank Helen for her enthusiastic response to the pocketbooks form, and for sharing her understanding of book design and the print medium. I would like to thank Ken Cockburn, Alison Humphry, Vicky Hale, Sophy Dale, Laura Coxson, and Cluny Sheeler at pocketbooks; Lucy Richards; Alison Bowden and Emma Darling at Polygon; the staff at Scotprint; and James Wilson at AK Reprographics.

Helen Douglas wishes to acknowledge the island of Muck as a source of inspiration: with its protective harbours, small sandy beaches, cliffs, and jutting rocks dashed by the Atlantic, it is a gem in its setting, but also vulnerable with a small population. She first visited Muck in 1959 and has returned many times as a child and adult. Helen would like to thank Judy Taylor and Ewen MacEwen, and Jamie who showed her his pool; Jenny and Lawrence MacEwen, who with others make the island so welcoming; also Sandra Mathers, and Clare and Brian Walters, who fortified her with a delicious bowl of soup one very stormy day. She also wishes to thank Charlotte Mellis on Mull.

Alec Finlay

Seashell to Ear

The seashore is an edge, perhaps the only true edge in a world whose borders are otherwise mostly political fictions, and it defies the usual idea of borders by being unfixed, fluctuant, and infinitely permeable. The seashore is the place that is noplace, sometimes solid land or rather sand, sometimes the shallow fringe of that huge body of water governed by the remote body of the moon in a mystery something like love or desire. A body of water is always travelling, and so the border between the land and sea is not a Hadrian's Wall or a zone of armed guards, it's a border of endless embassies, of sandpiper diplomacy and jellyfish exportation, a meeting or even a trysting ground. An open border but a dangerous one between the known and the unknown, which only a few sibyls, amphibians, crustaceans and marine mammals traverse with impunity. The shore is also the site of the mutual offerings of the dead, our drowned, their beached, another edge effect, this washing up of corpses, metaphors, myths. The mind is likewise such a meeting ground: its ideas are less often laboriously thought out than suddenly washed up from unknown hatcheries and currents far beneath the surface, as if consciousness were just the shore on which fluid ideas get stranded and are by the quick retrieved before they rot or are seized by distraction's seagulls. The dry ideas of logic that drown in the sea, the dreams that like whales die crushed by their own weight when they wash up on shore in the morning, and amphibious poetry inbetween – for the seashore also suggests the border between fact and imagination, waking and sleeping, self and other – suggest perhaps the essential meeting of differences, essential as in primary, essential as in necessary. Wandering the coastline with downcast eyes to find what there is to be found, a material correlation to composing and thinking, is a disreputable profession with

its own word, beachcombing. Shopping at one's feet for stories, for the unknown, for the thing lost so long one can no longer name it, for treasure that will transform, for that inhuman material that sets free whatever is most human. For adults there is the question of how to set the eyes – whether to beachcomb or more upliftedly regard the view of sea and land – but for children, who have not yet learned that rocks and shells dry and out of context will generally dwindle into rubbish, combing the beach is irresistible. Beachcombing, to comb the beach as though it were the hair those mermaids are forever combing with one eye on the sailors, for there is a litter of images, inspirations that are more portable and better looking removed from the shore than its physical stuff. Generative graveyard, this coastline littered with shells from which the dwellers have been evicted, sailor-strangling seafoam, and says Rachel Carson at the beginning of her book *The Sea Around Us,* 'Mother Sea'. 'The sea floats her, ripples her, flows together with her daughter, in all our ways,' writes Helene Cixous, 'Then unseparated they sweep along their changing waters, without fear of their bodies, without bony stiffness, without a shell . . . And sea for mother gives herself up to pleasure in her bath of writing.' Fluidity, Aphrodite of the unsanitary seafoam rather than of marble, generated when Chronos, or Time, threw Uranus' severed genitals upon the open sea, beauty daughter of violence and flux. The sea is a body in a thousand ways that don't add up, because adding is too stable a transaction for that flux, but the waves come in in a roar and then ebb almost silent but for the faint suck of sand and snap of bubbles, over and over, a heartbeat rhythm, the sea always this body turned inside out and opened to the sky; the body a sea folded in on itself like a nautical chart folded up into a drinking cup. A person who nearly drowns is more

readily revived if her lungs are full of seawater than freshwater, for the sea just as salty as the body does not dilute the blood and burst the cells. It was the sea in which all life evolved we were all told long ago, and somewhere further along in biology blood became one kind of salty ocean circulating nutrients, oxygen, flushing toxins and detritus along the estuaries and channels of the body, and amniotic fluid another sea in which each floated in darkness the first nine months of life until, as they say, the waters broke. But where I come from the first people say that originally Coyote or Raven or Creator drew solid land up as a fistful of mud from the spreading waters, and the ones who live on the coast say that the dead go west over the sea when they die, the place that every river on this Pacific slope runs to. Another story from this terrain has the earth as Turtle Island, a swimmer forever afloat in the sea, and all these stories assert that the liquid is primary and solidity merely floats on it (and the night before I go to this coast to think out this essay, I dream I am carrying a tortoise or turtle before me in two hands, held out before me like an altarboy's Bible, and the creature keeps leaking water, far more water than ought to be in its body, and only upon waking do I realize that the room around which we proceeded was my childhood bedroom). One thing leads to another: there are the seashells children are told to hold to their ears to hear the sea, and only later are they told that they are listening to the inward sea of their own body's pulses echoing in the seashell that was itself once a favorite metaphor for a delicate ear: these are pearls that were his eyes, but seashells that were her ears. Pearly-eyed Alice cries an ocean and then swims in the sea that flowed from her eyes to the strange world on the other side of her tears, and the American artist Robert Gober's 'Madonna' comes flanked by

two suitcases full of tidepool life that seem like allegorical wombs, for though it is obvious enough that rivers are veins and arteries, the ocean is everything. Call it a sea of amniotic fluid, the fluid in which life generated, but uterine hardly describes this most open space under the sky unless to the most wide-open imagination. The seashore, everything always in motion, a place that seems the essence of change, but the pelicans that skim the waves look like pterydactyls and the trilobites scuttled blindly through the coming and going of the dinosaurs without any more interest than they take in, say, photography with its womblike darkrooms and developing washes, or in politics or in poetry. The sea lapping like a cat at a saucer of milk or rather since it is the liquid that acts, the sea like a vast saucer of milk lapping at a recumbent cat. The sea laps at the land, or the sea is in the lap of the land, the ancient earth whose unseen depths cradle the seas and whose heights we inhabit mostly at the altitude called sea-level which global warming will change and with it outdate all the coastal maps, but what about this lapping in the lap? This is not quite the allegory meant in old movies when sex was implied by a cut to the waves whose steady rhythm had more to do with hips than lips. "Yes, as everyone knows," remarks *Moby Dick*'s Ishmael when he's still on shore waiting to ship out, "water and meditation are wedded forever," asking us to accept the play on the liquidities of language in which the substance and the cerebral act can be imagined as married like two members of the same species, a pairing like beauty's parentage of severed genitals and seafoam. 'In all rivers and oceans,' says Melville a little later, 'is the image of the ungraspable phantom of life; and this is the key to it all.' The linear narrative of following the coast, the plot, the history, the sequence of pages versus the steady rhythm of the

tides, the waves, the desires. The book and the sea turn into each other at the end, a stranding of black letters on the white shore of the book, and the pages of a book at the windy seashore blow one over another like waves, a curl, a comb of pages. The box of a book is a misleading shape, call it a pirate chest made to be opened, call it the long thread of a story wound up on the spool of a book's solid shape, every pagespread a valley landscape, though the term gutter urbanizes the central cleft between the pages. Open a book and look at it endwise and it looks like a bird seen in flight far away, spine for body and pages for wings, a fat black bible like a raven, slender art book with thinner curves of pages to either side like an albatross. This book could be bound as a circle, the pages like spokes on a wheel, a turning investigation of the sea, a continuity that folds back on itself, a walk that went all the way around an island to end at its beginning, or it could be imagined as an aquarium, every page like the Madonna's tidepool suitcases a sample so fresh that some pages seem to splash, to have depth the hand could plunge into to seize some of their treasure. Walk on the seashore: strands of seaweed lie hieroglyphically upon the strand and are sucked up by the sea and like words turned back into fluid ink waver in the water before being cast up on the sand in another equally unreadable version, roll of the dice, toss of the yarrow sticks. Reading the sea, transparent at one's feet, green as arching wave and white as spray, its depths an opaque accumulation of transparencies with blue borrowed from the sky. Building a museum case and filling it with types of mussels is one way of knowing mussels, but on the shore a mussel leads to a crab or a cockle or a curious pebble, which leads to another thing and eventually leads to mussels, which is another and perhaps a truer way to know mussels. The sea that always seems like

a metaphor but one that is always moving, cannot be fixed, like a heart that is like a tongue that is like a mystery that is like a story that is like a border that is like something altogether different and like everything at once. One thing leads to another, and this is the treasure that always runs through your fingers and never runs out.

Rebecca Solnit

Unravelling the Ripple

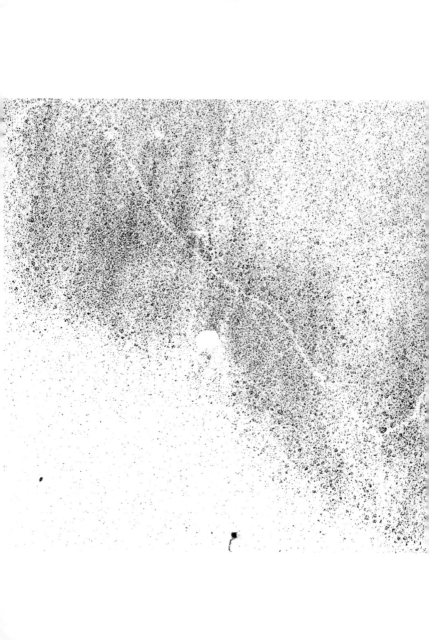

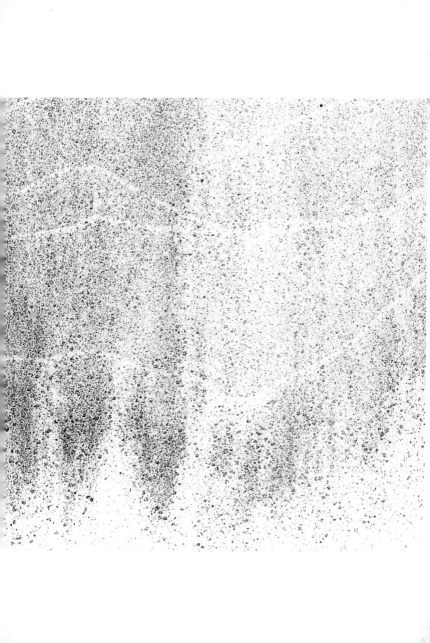

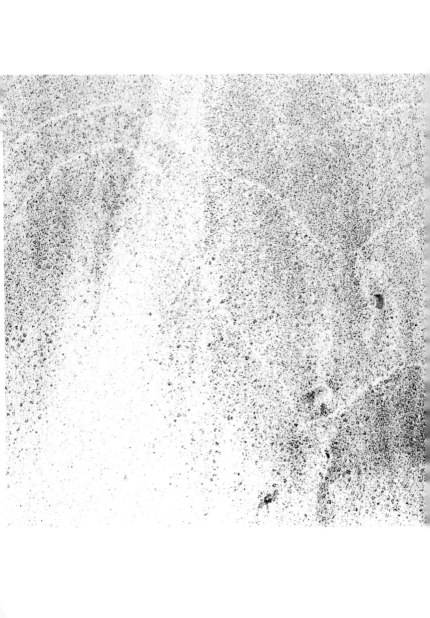

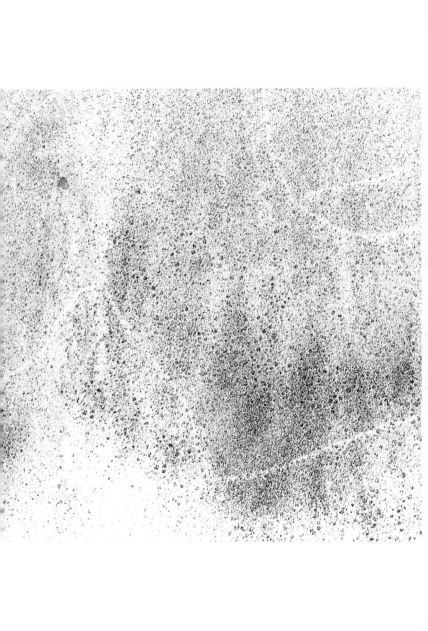

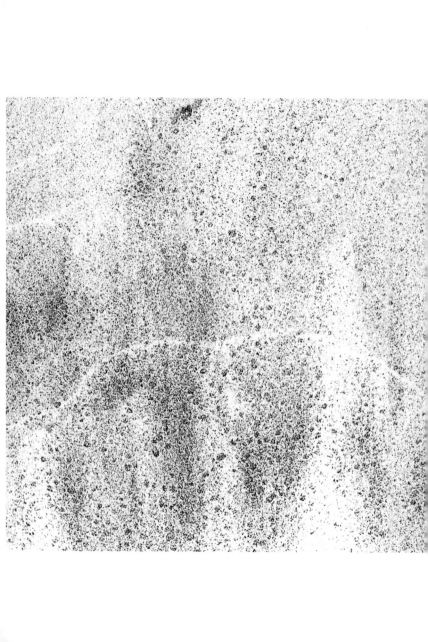

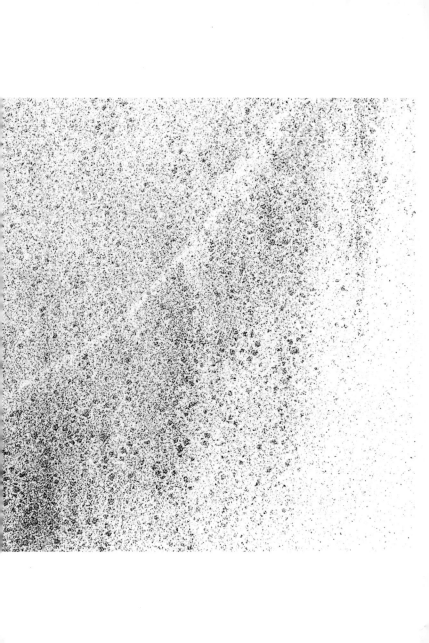

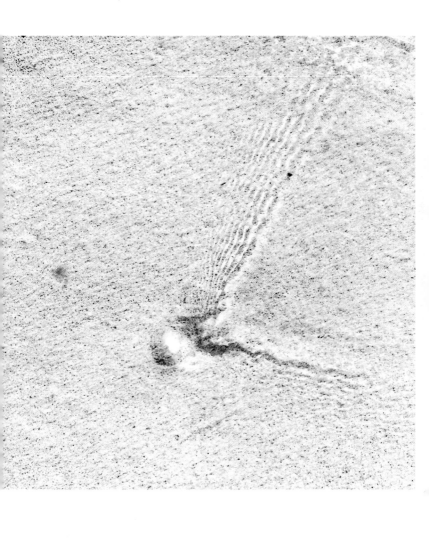

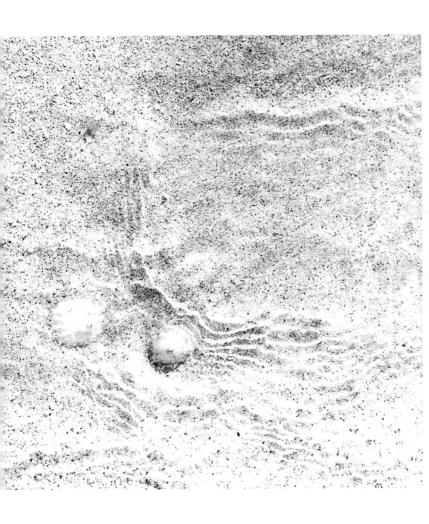

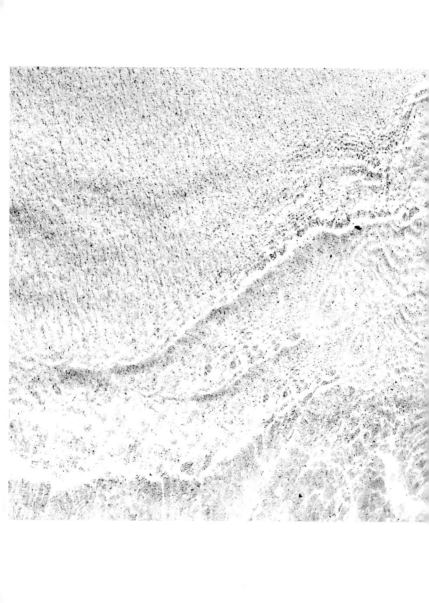

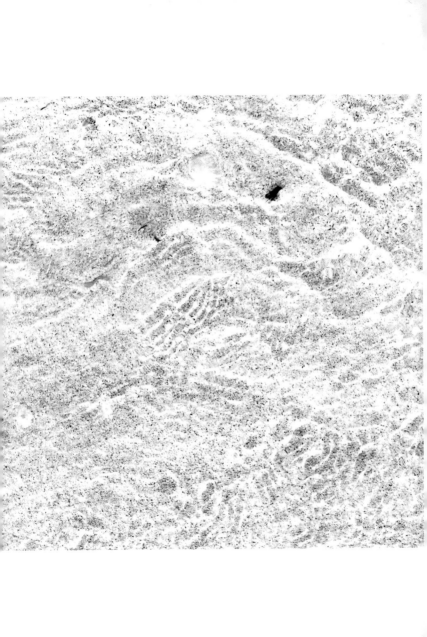

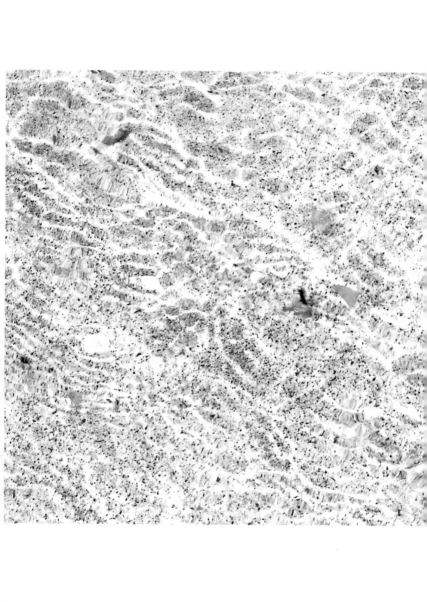

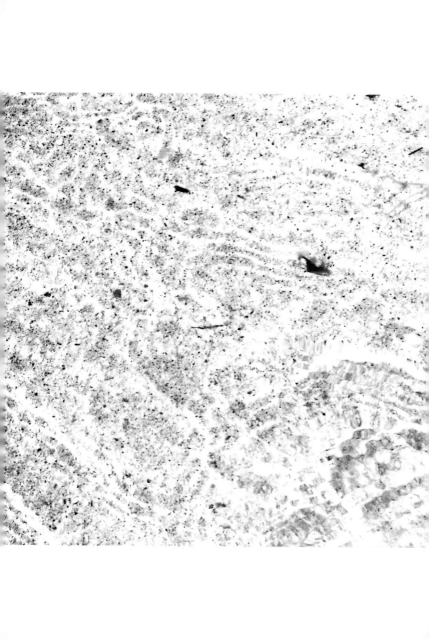

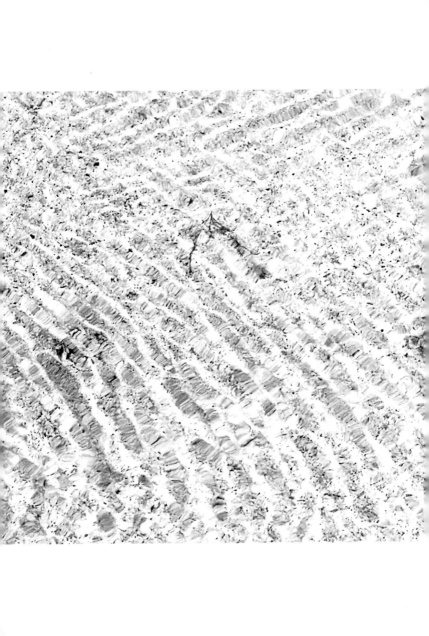

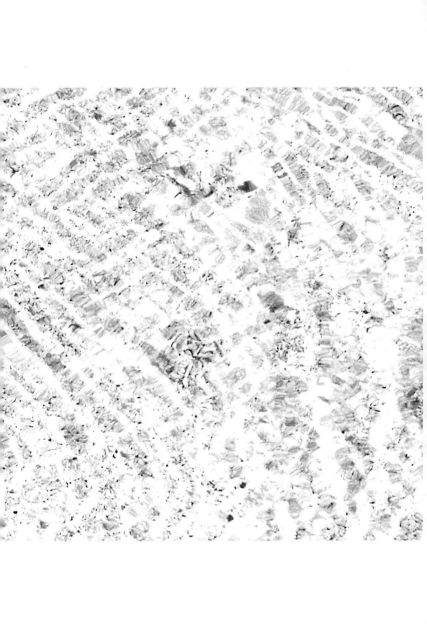

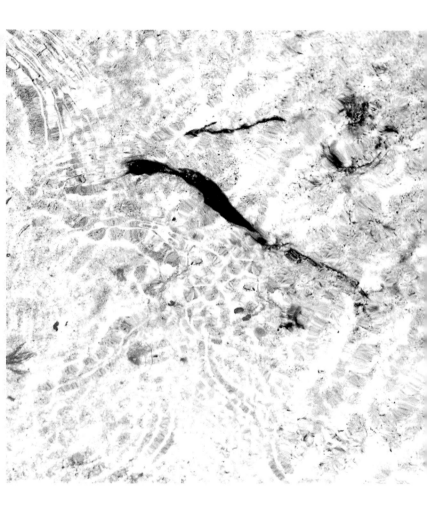

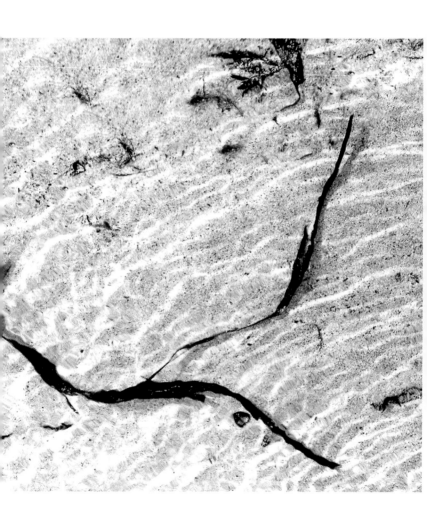

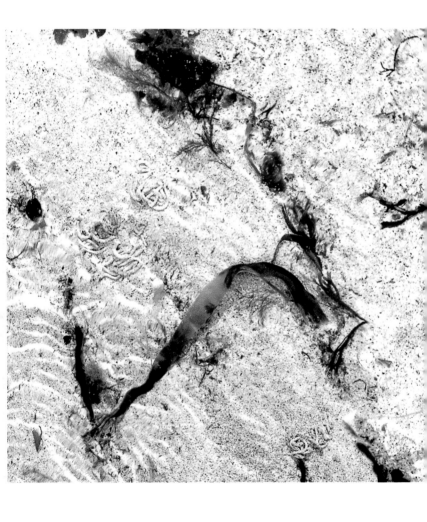

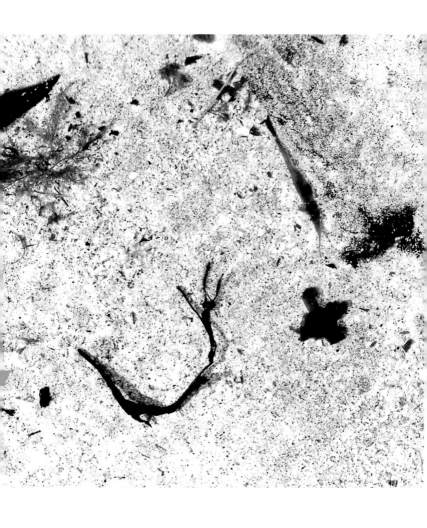

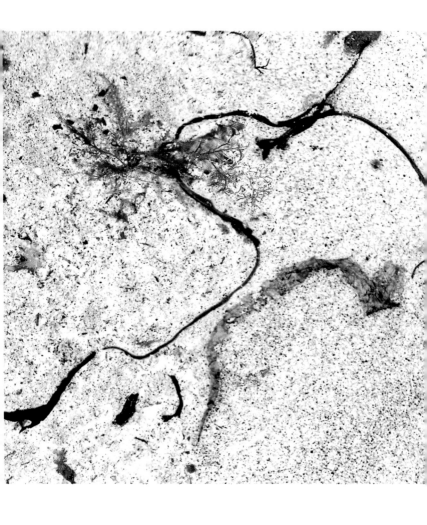

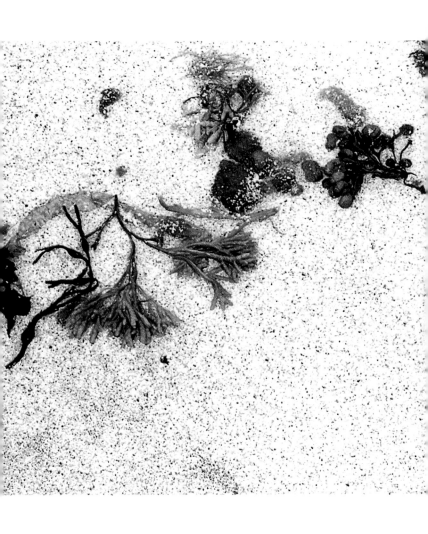

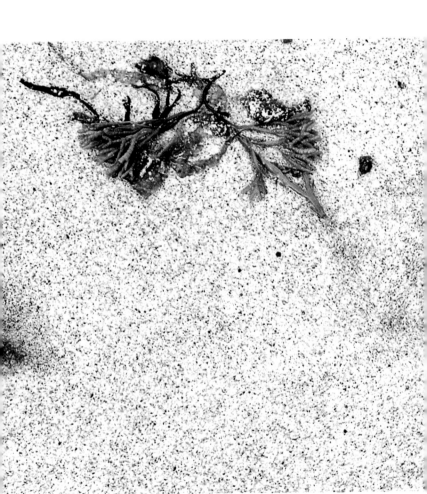

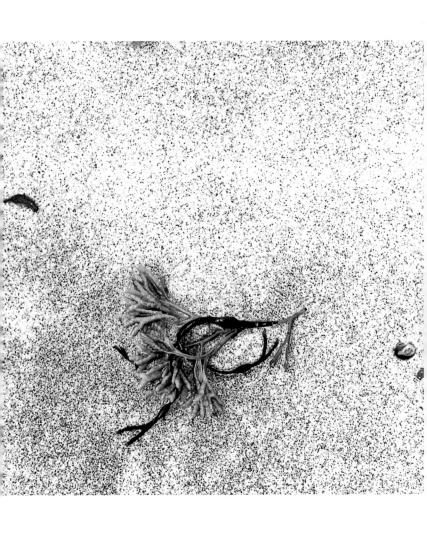

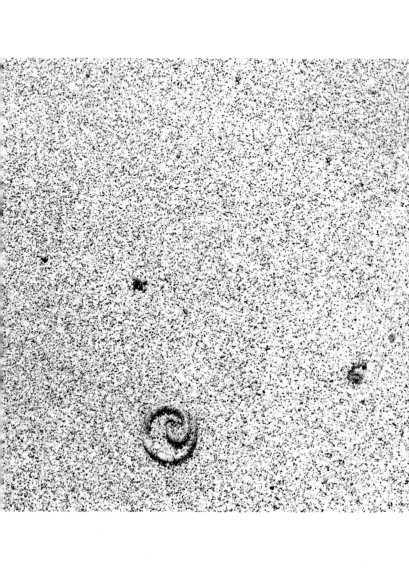

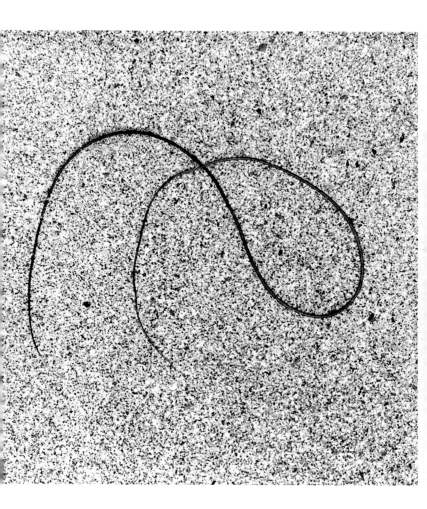

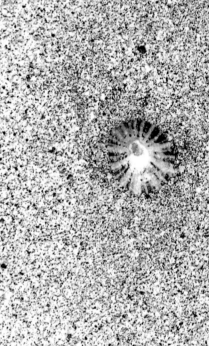

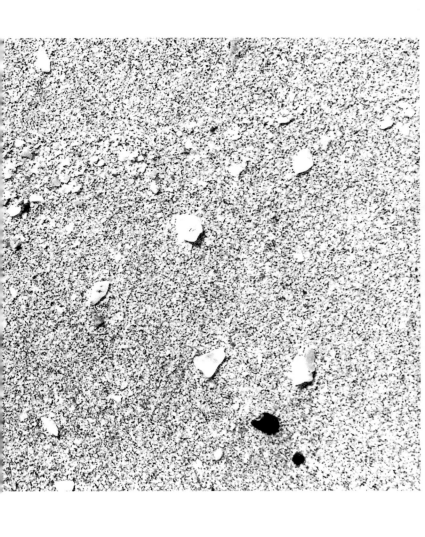

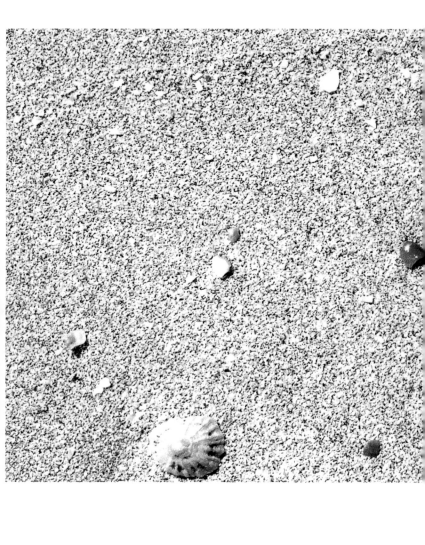

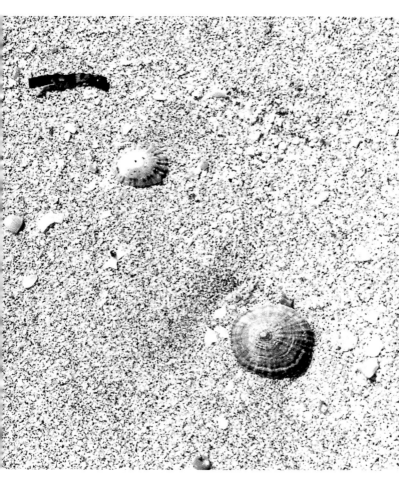

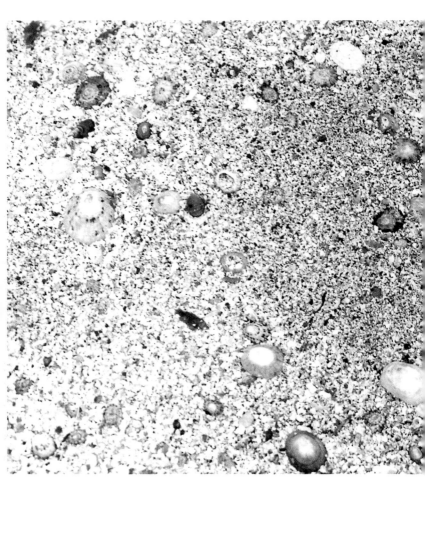

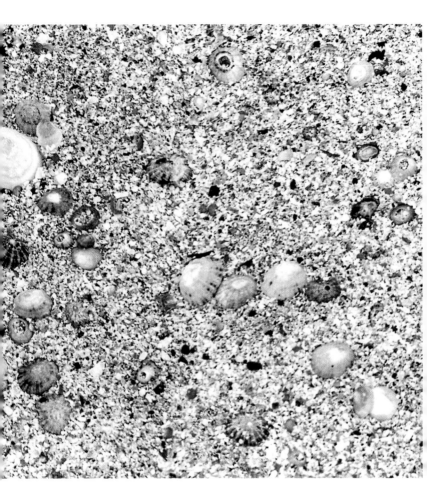

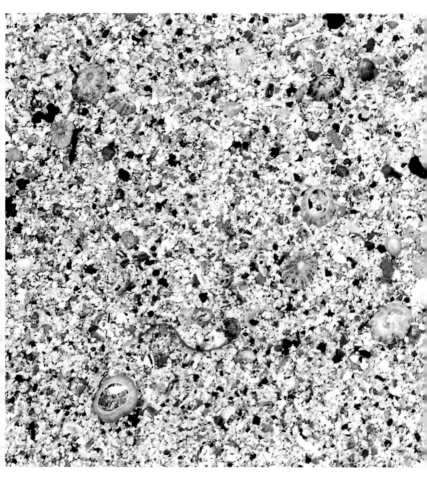

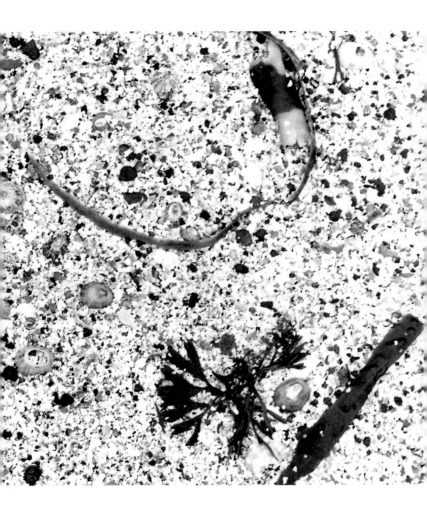

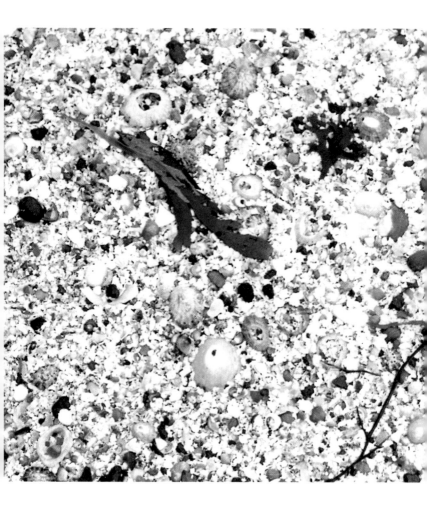

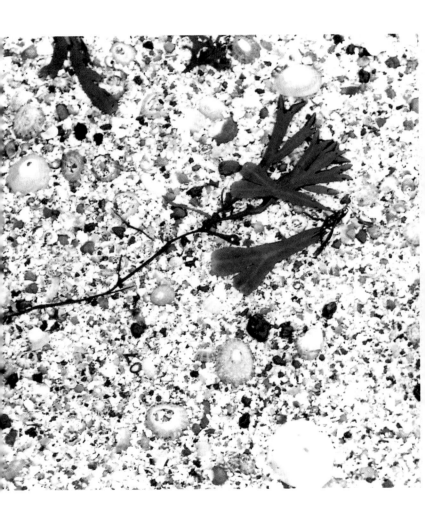

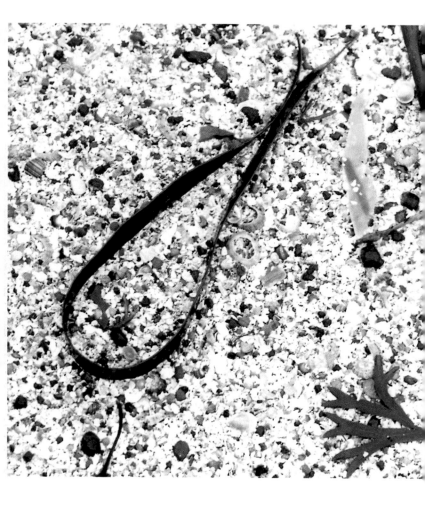

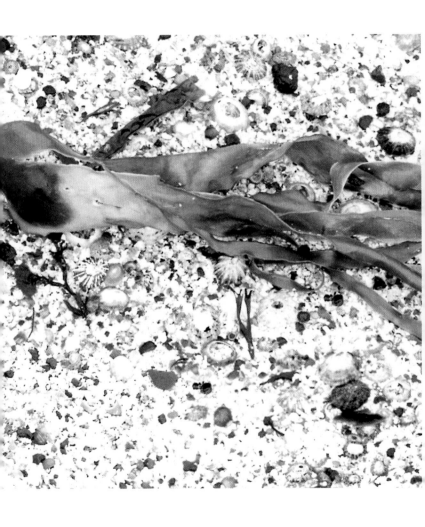

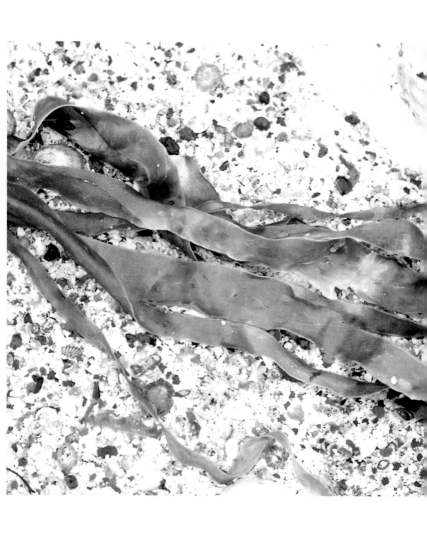

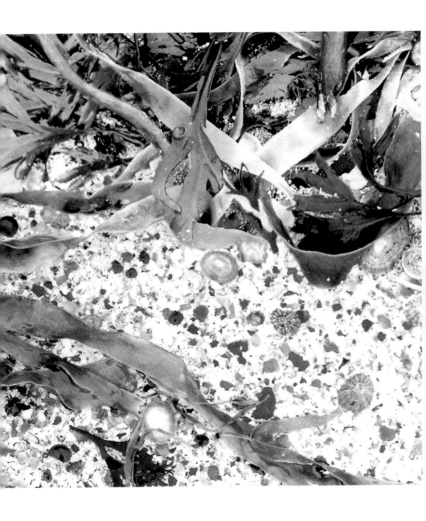

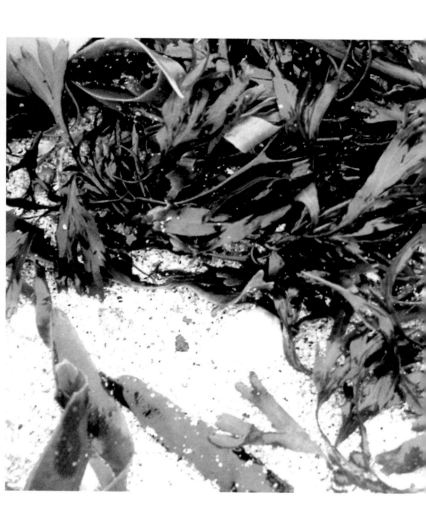

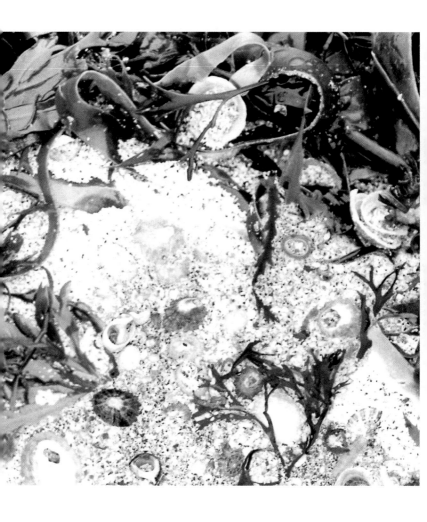

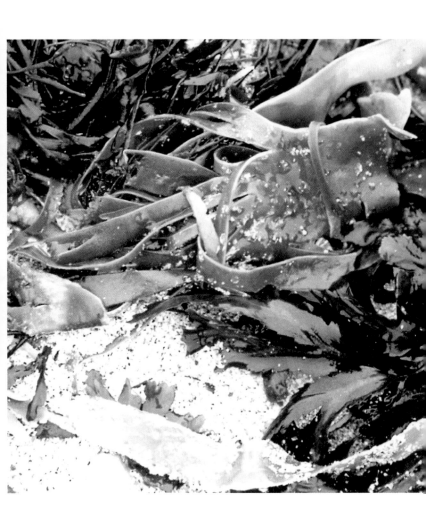

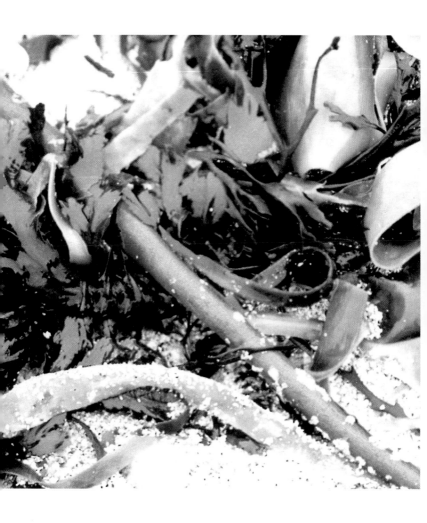

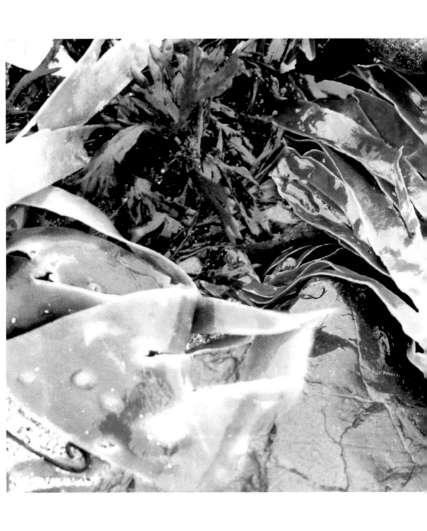

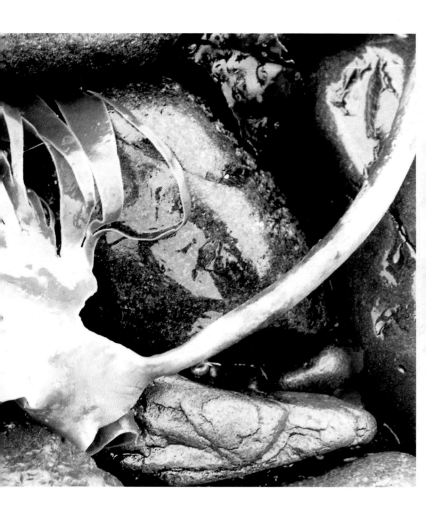

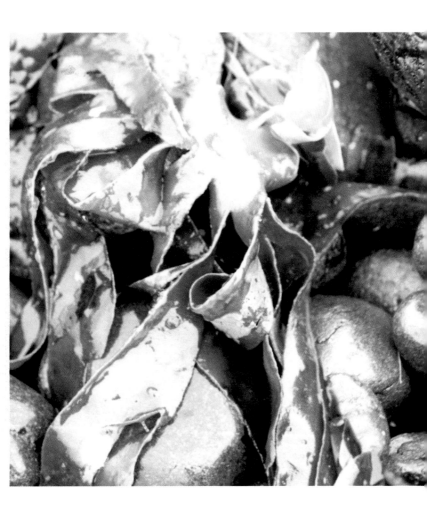

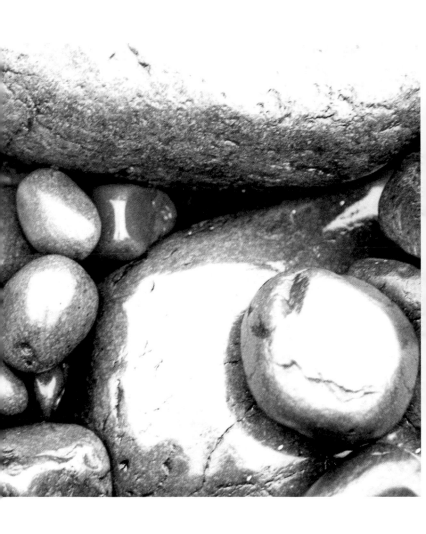

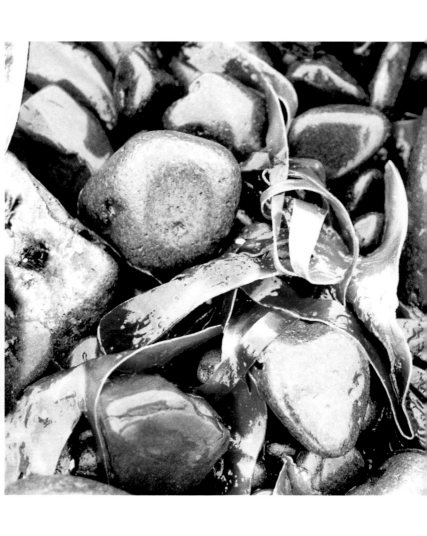

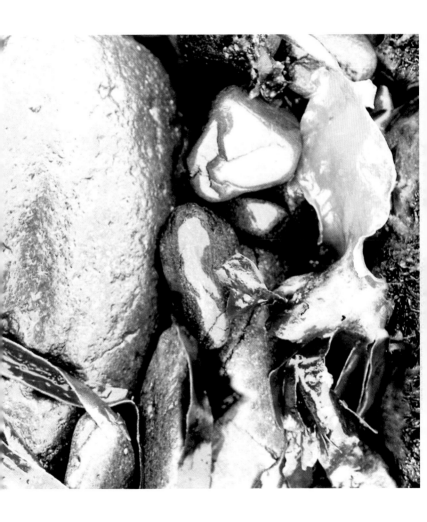

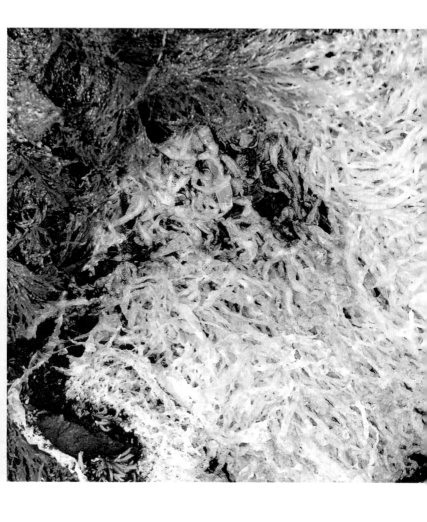

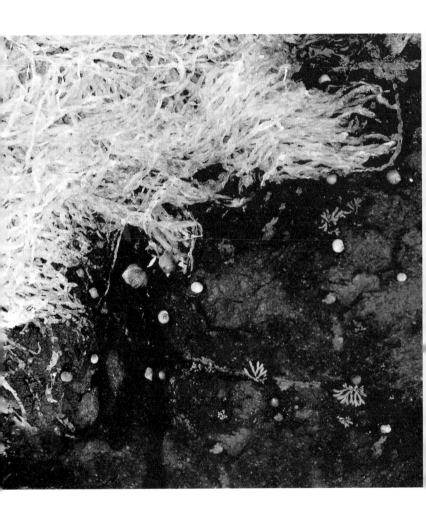

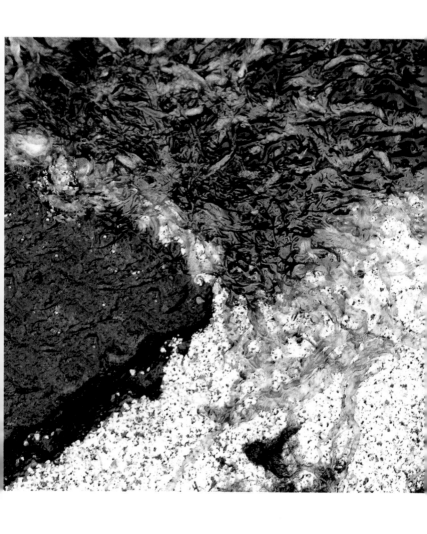

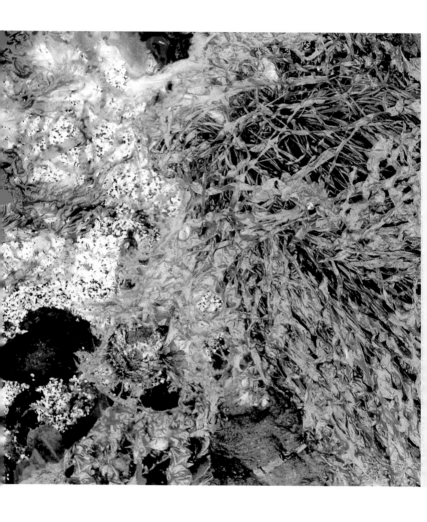

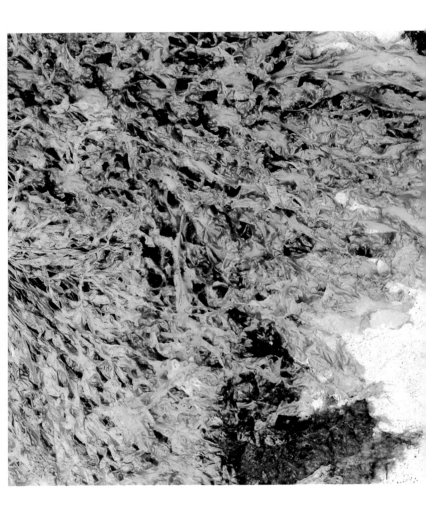

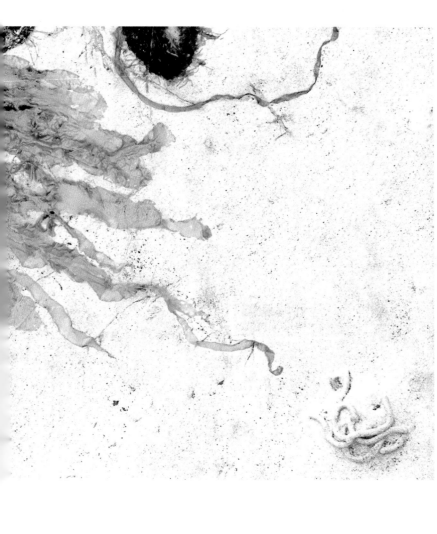

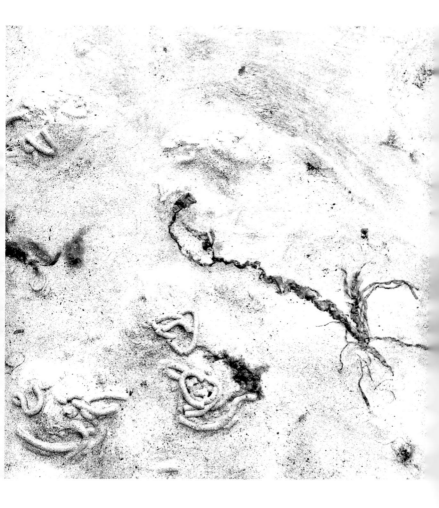

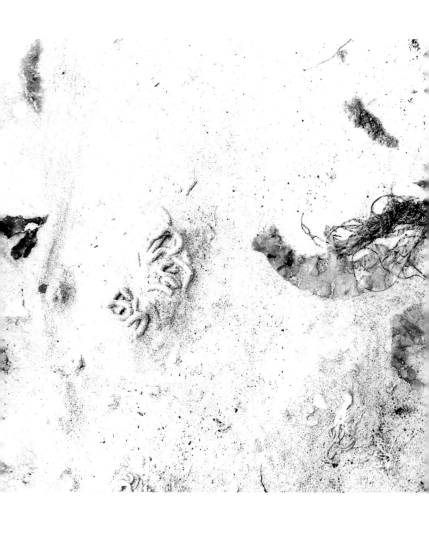

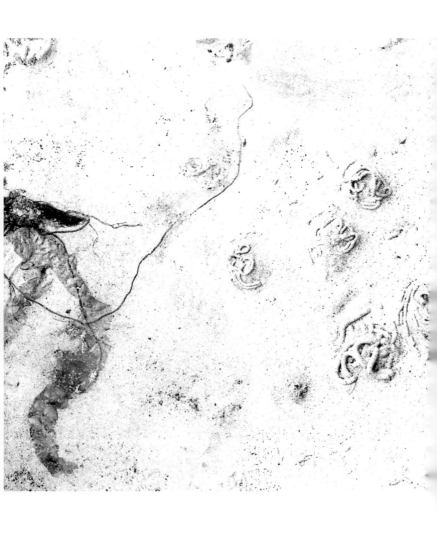

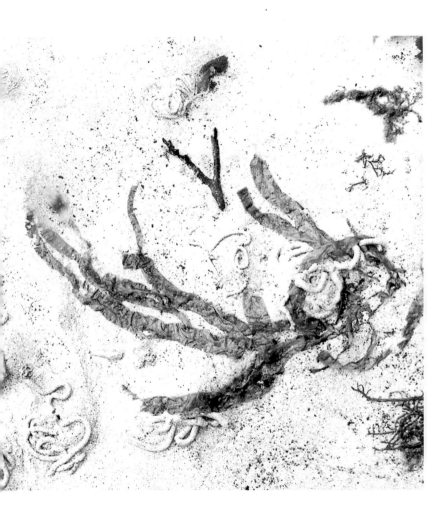

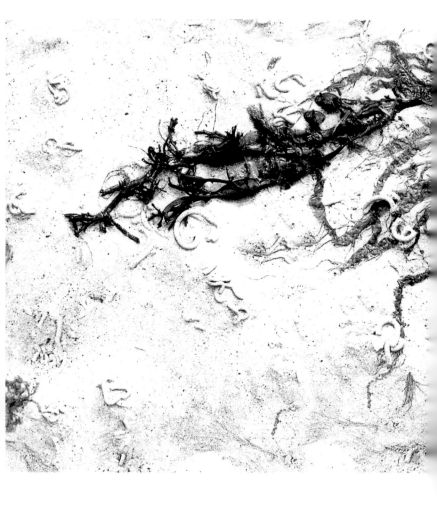

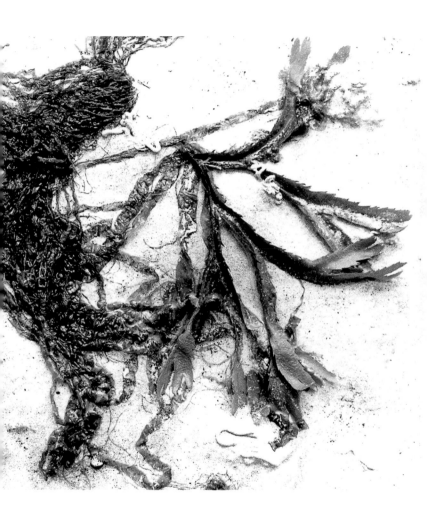

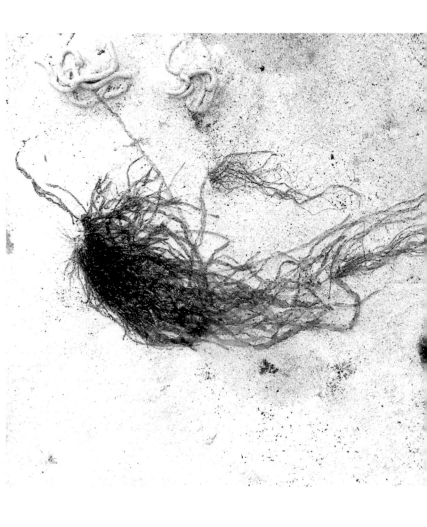

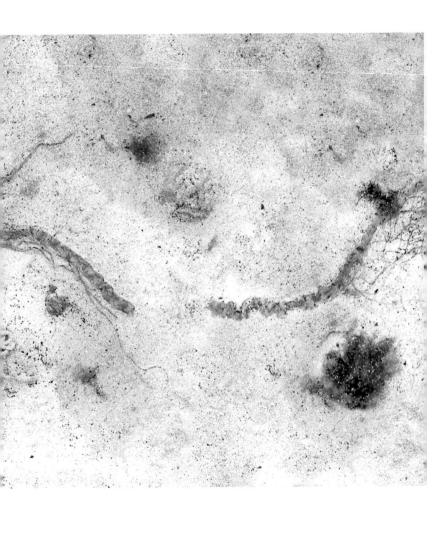

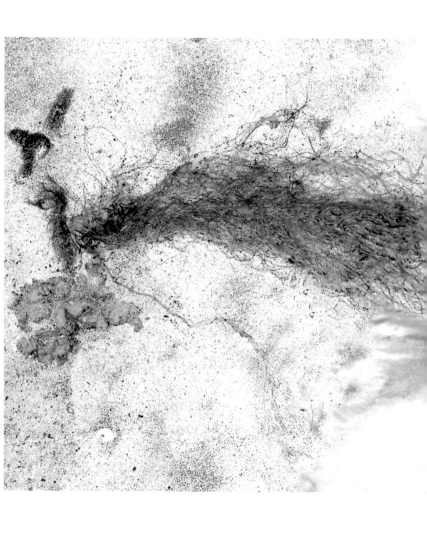

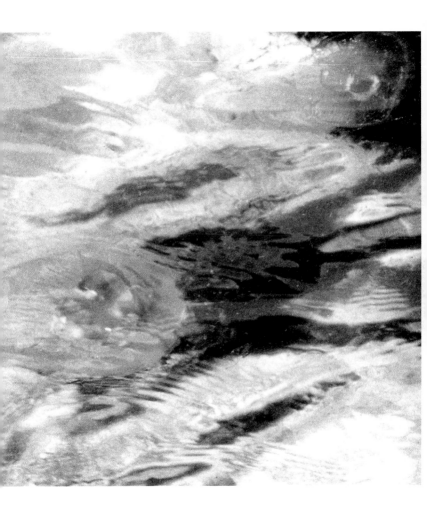

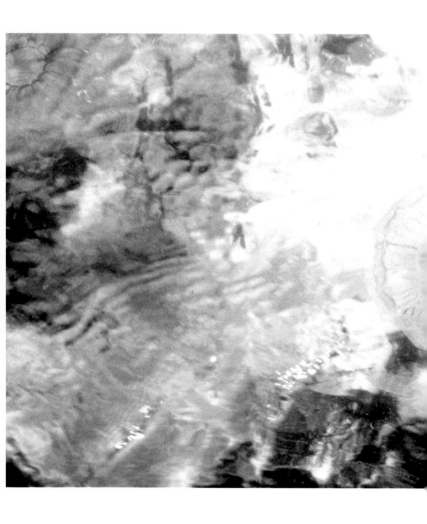

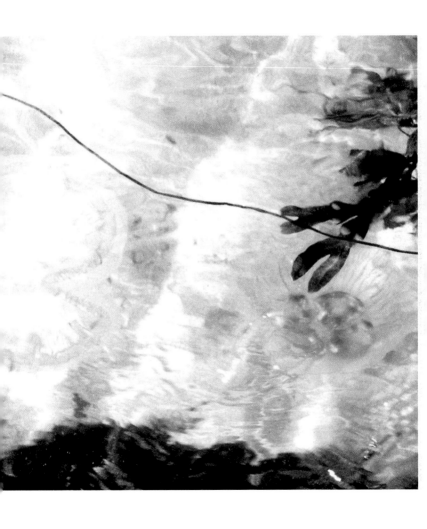

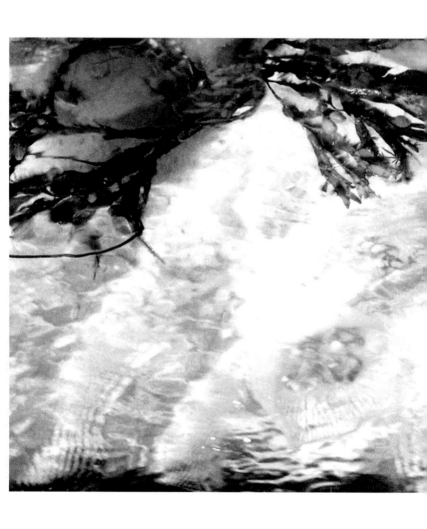

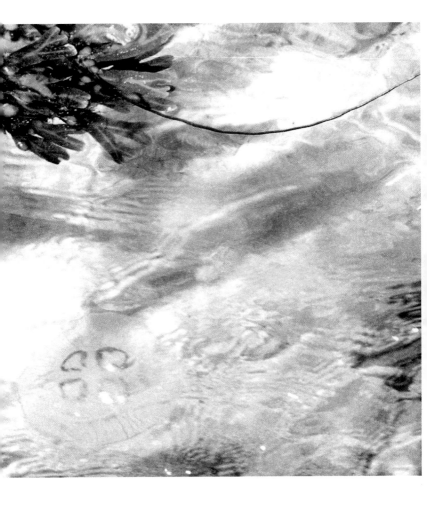

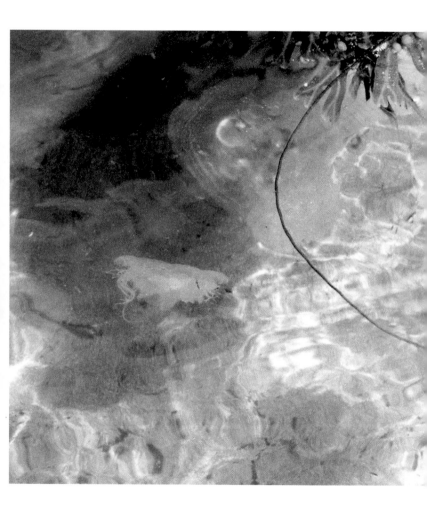

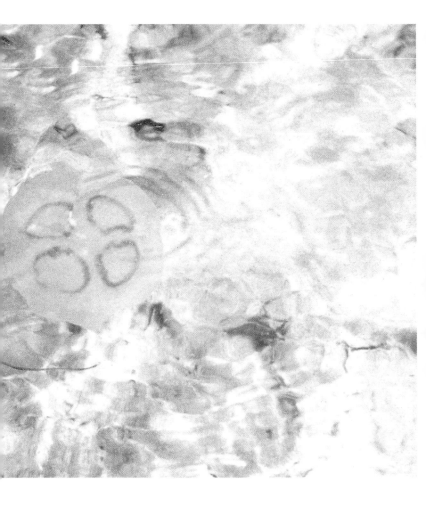

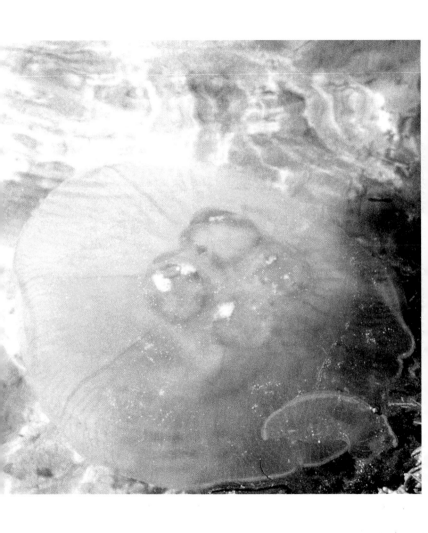

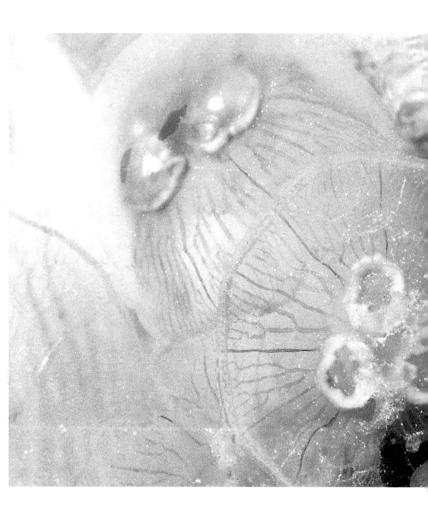

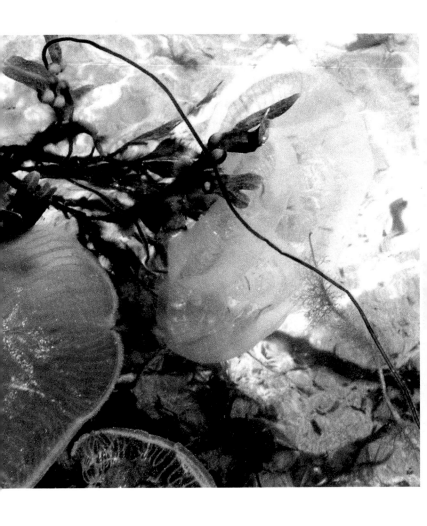

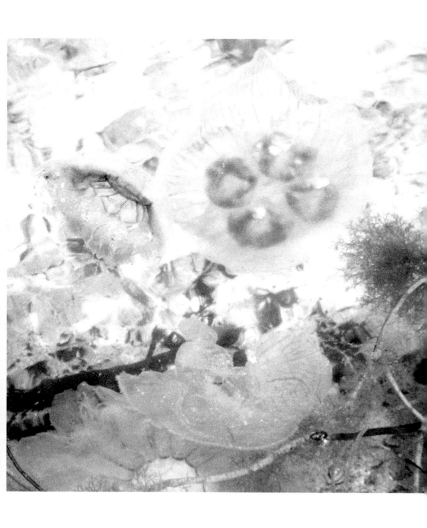

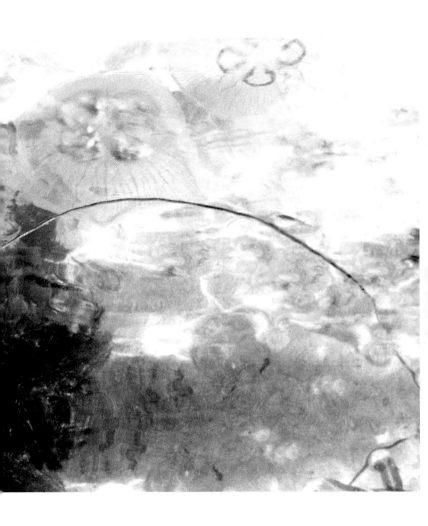

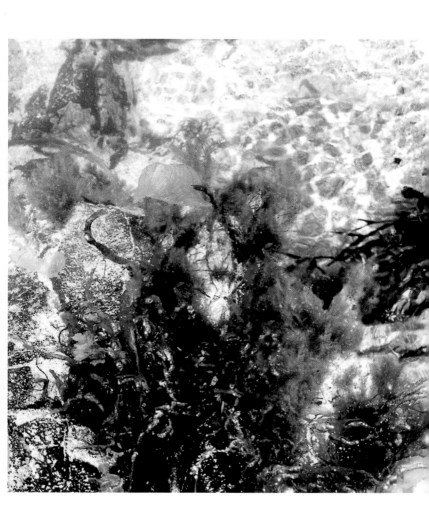

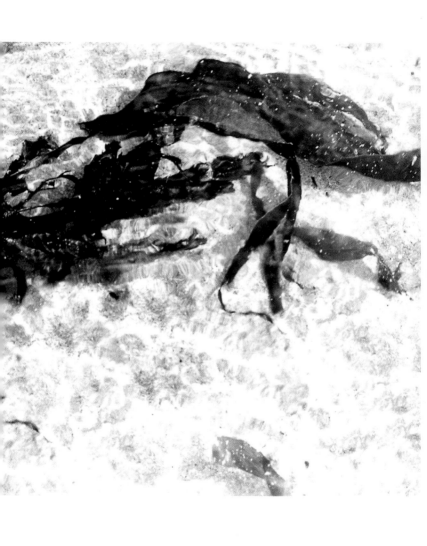

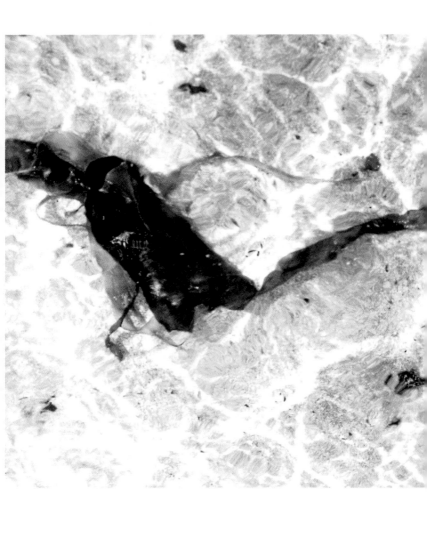

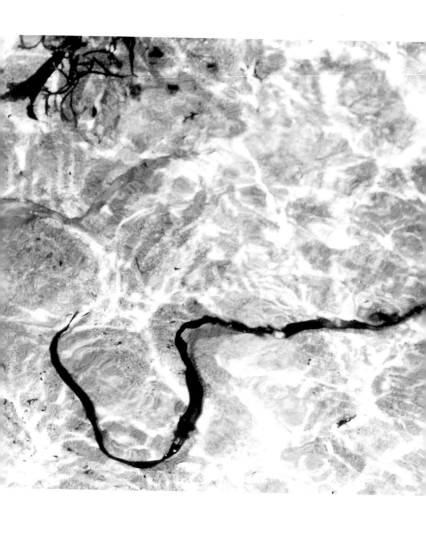

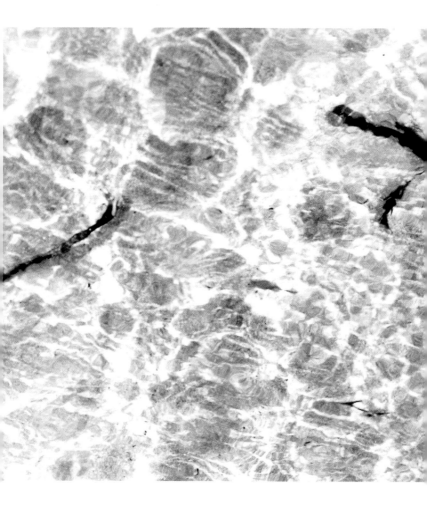

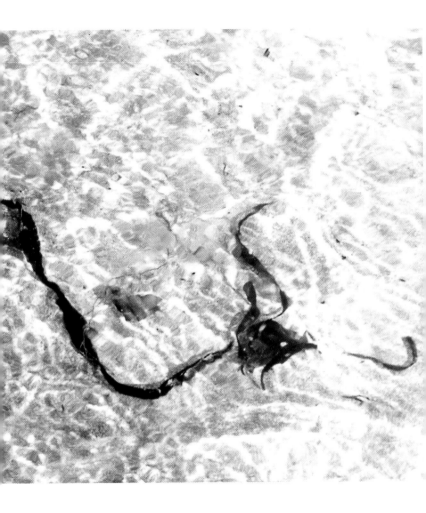

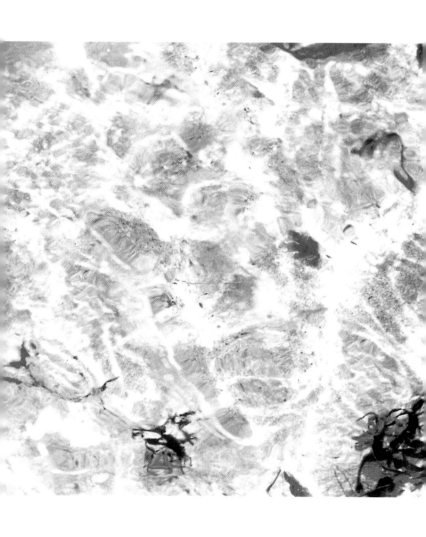

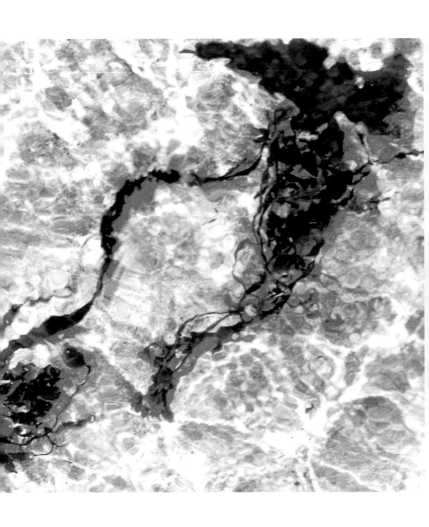

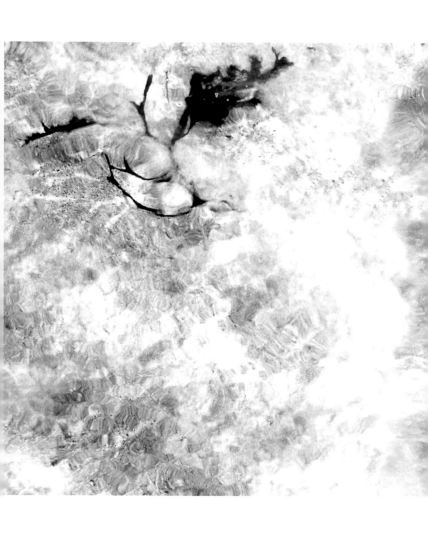

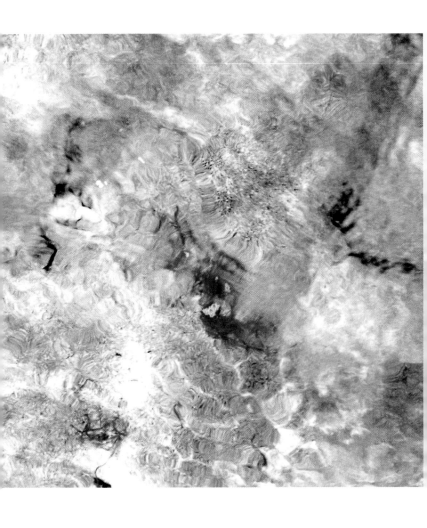

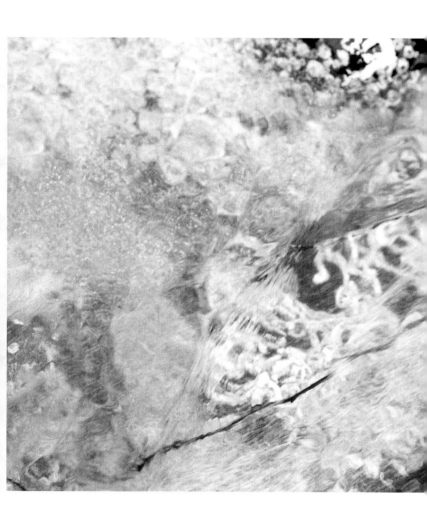

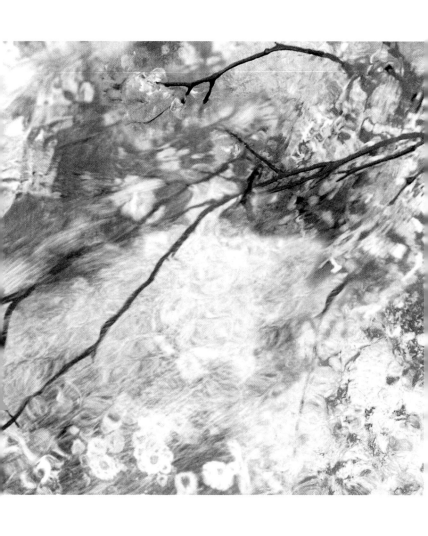

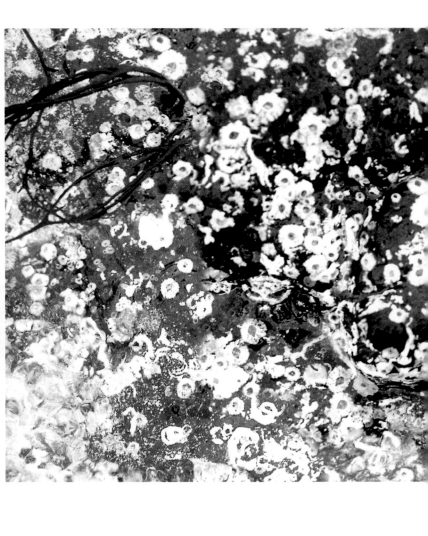

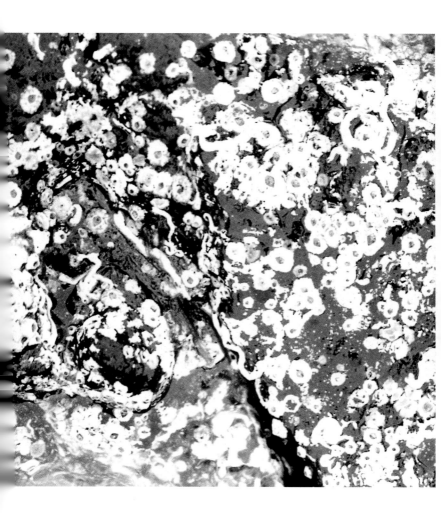

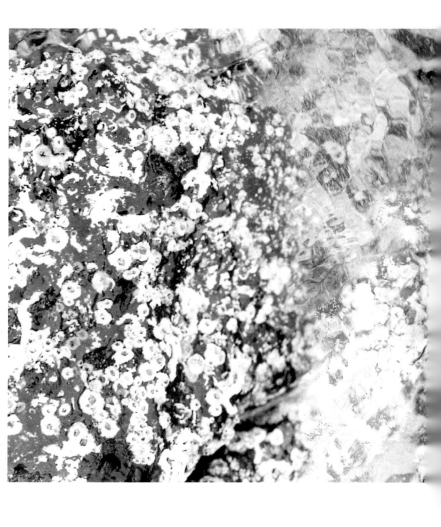

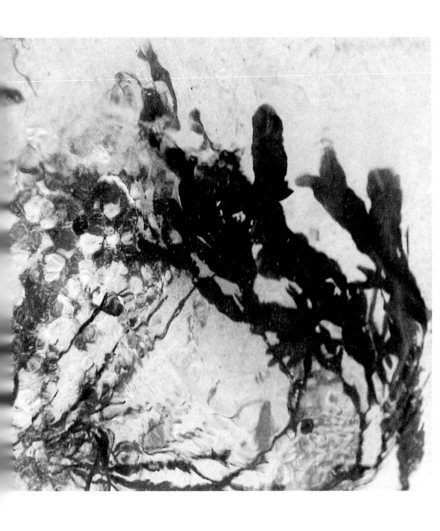

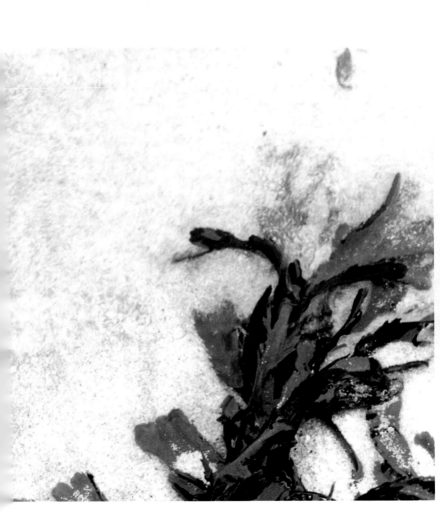

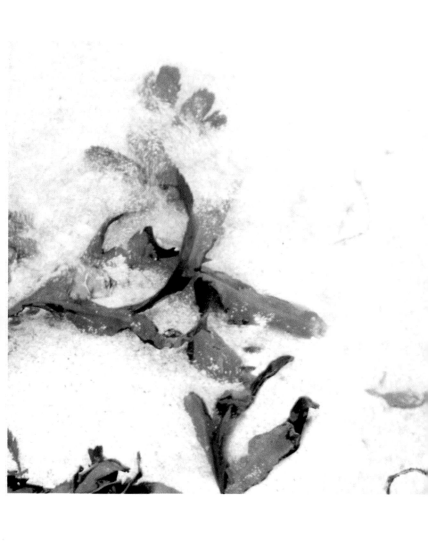

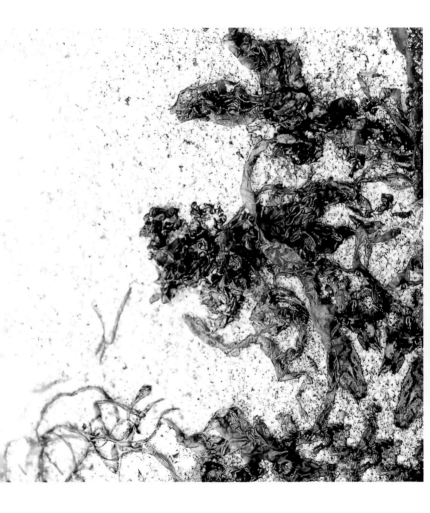

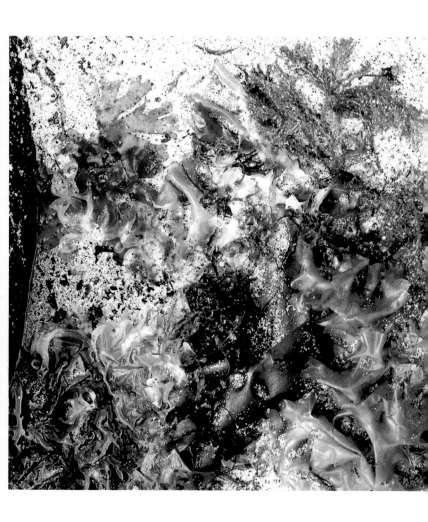

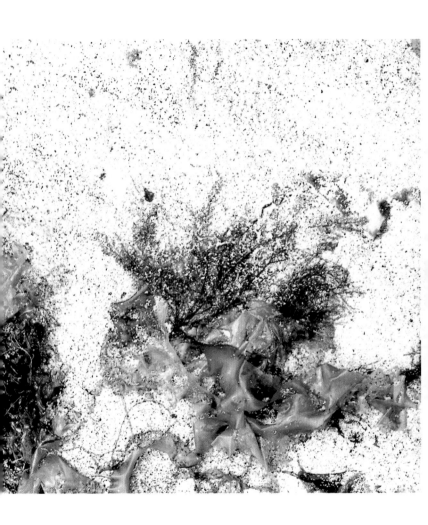

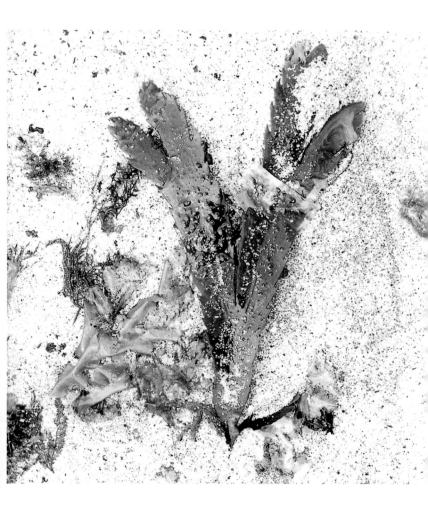

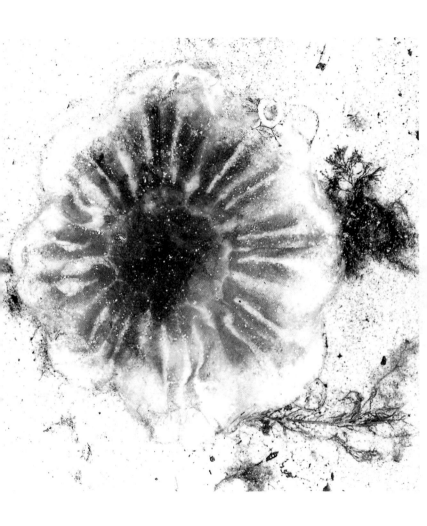

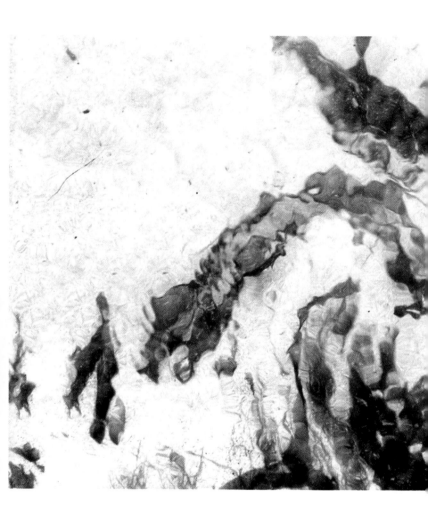

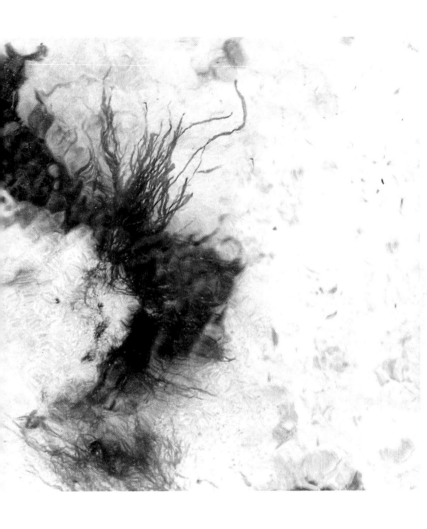

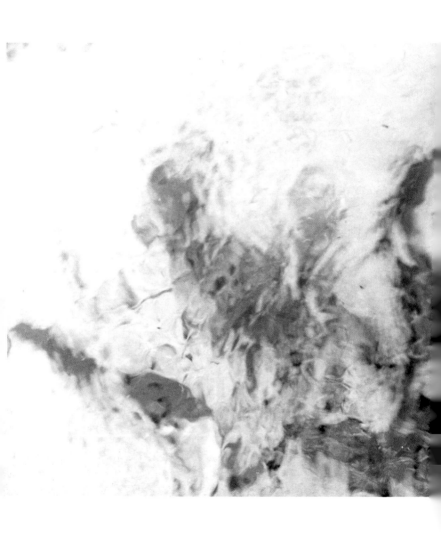

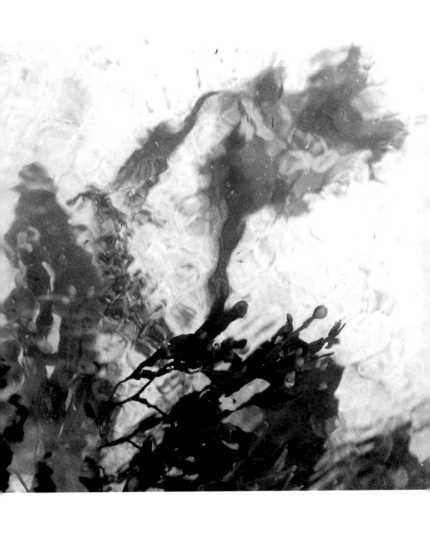

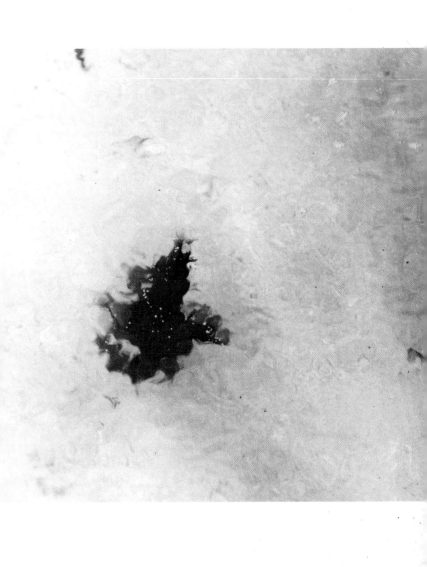

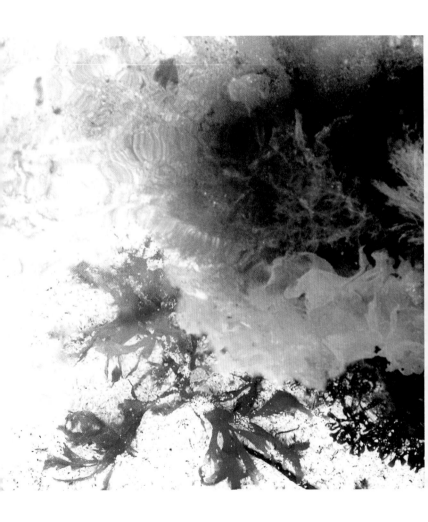

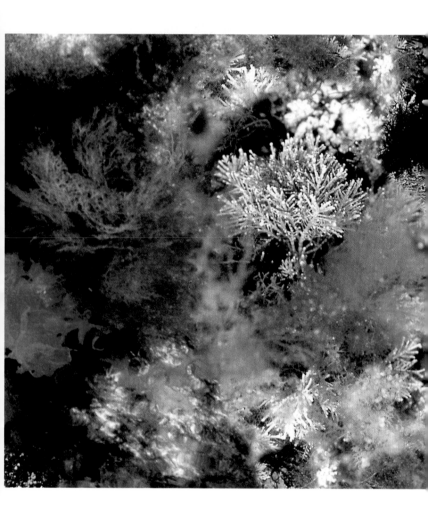

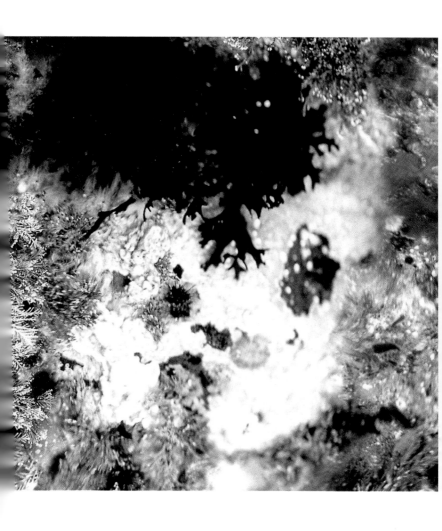

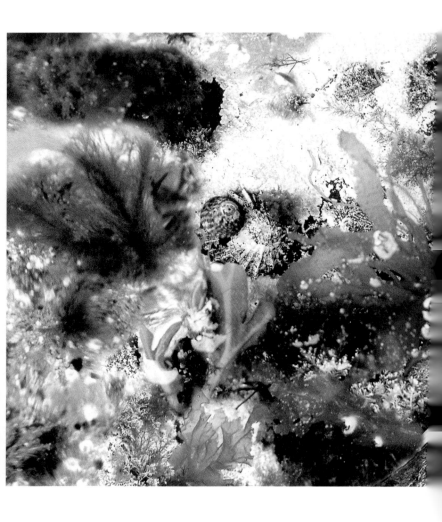

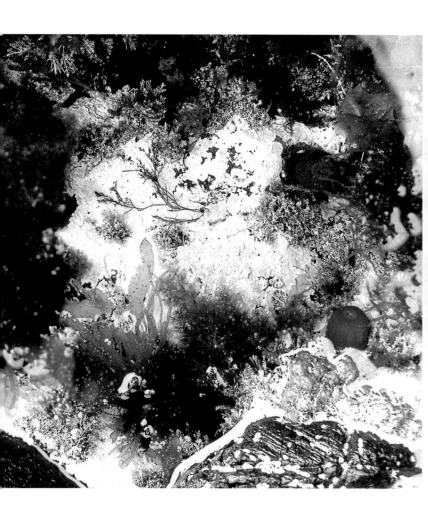

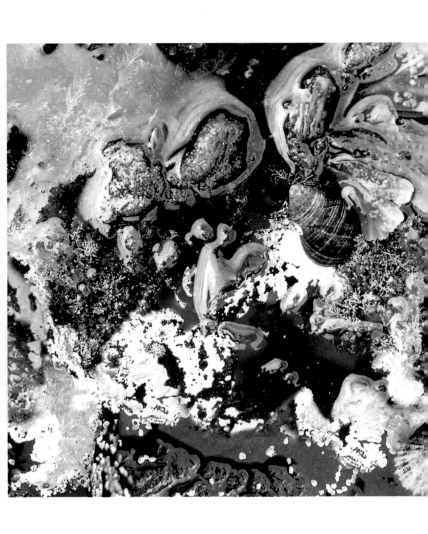

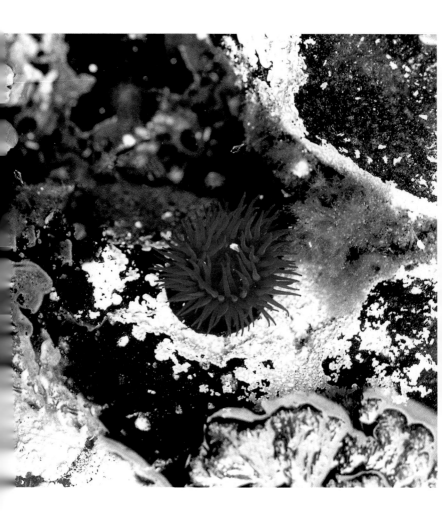

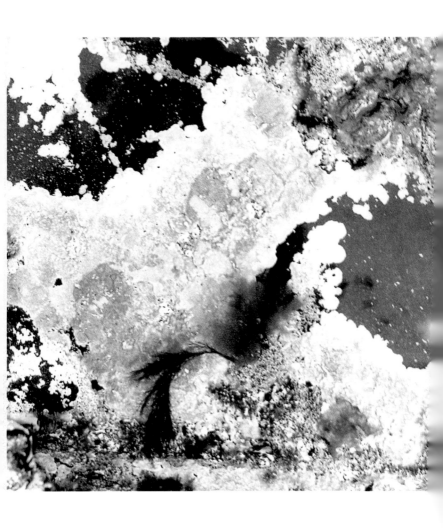

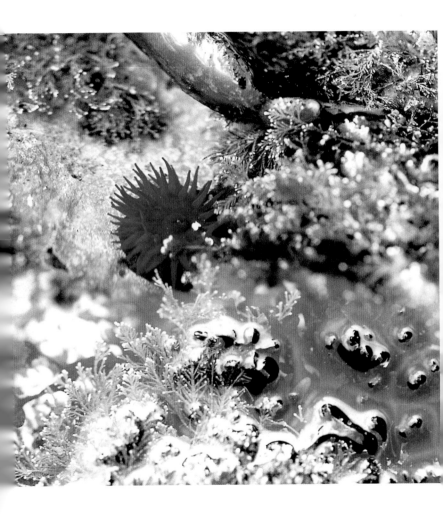

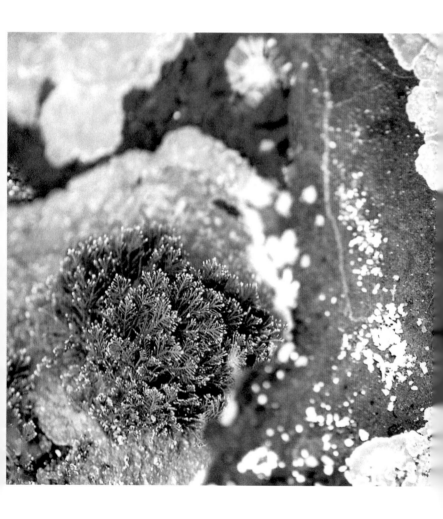

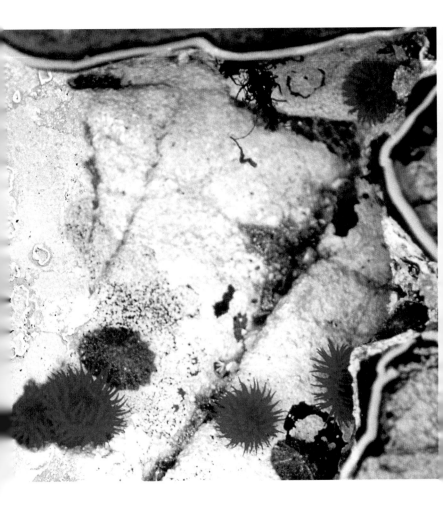

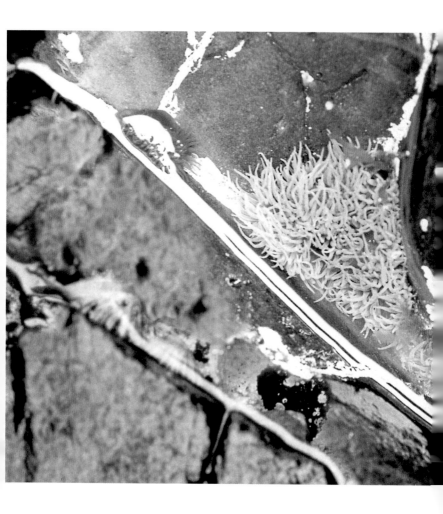

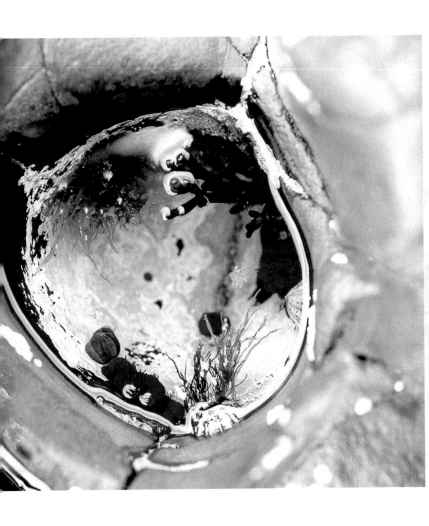

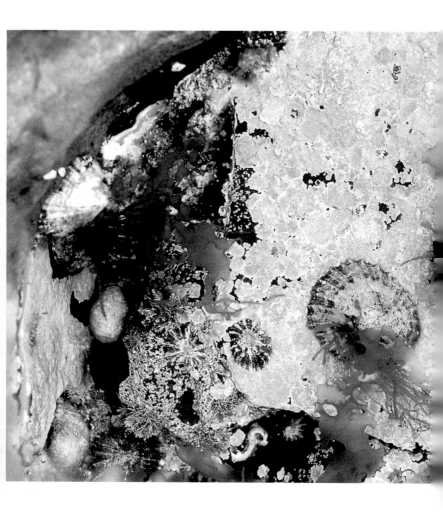

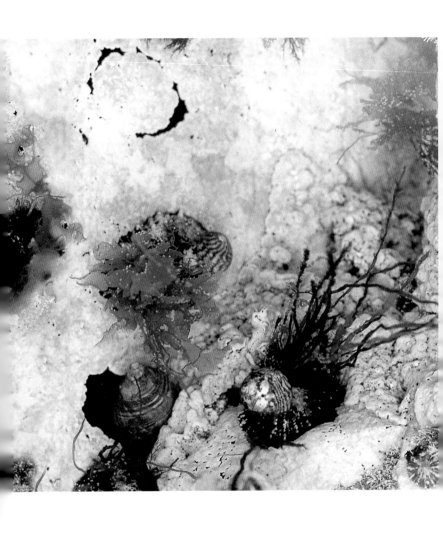

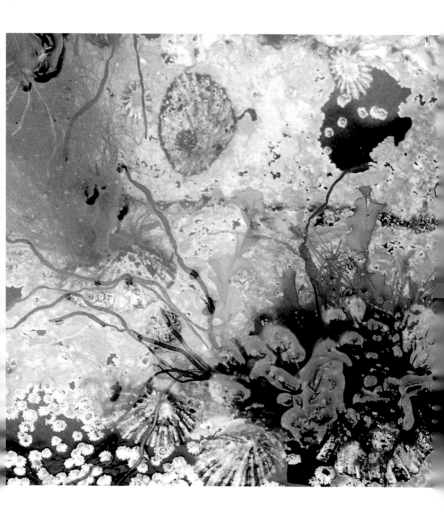

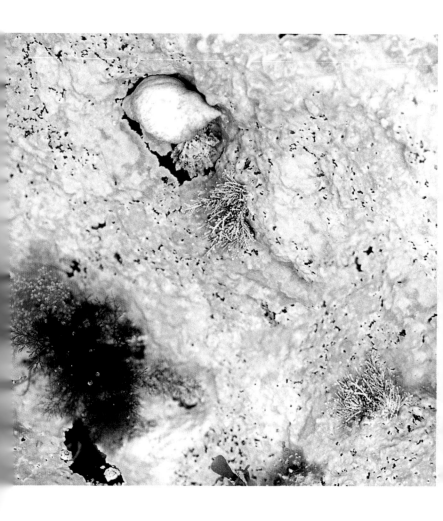

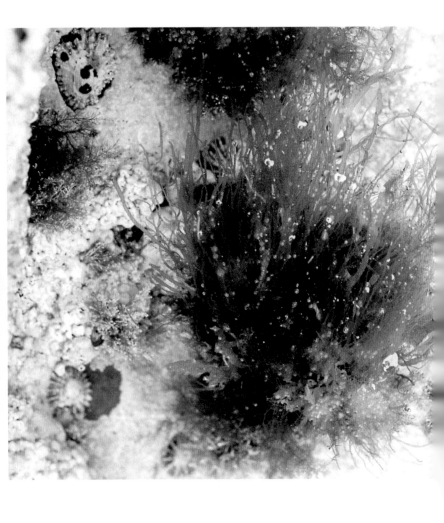

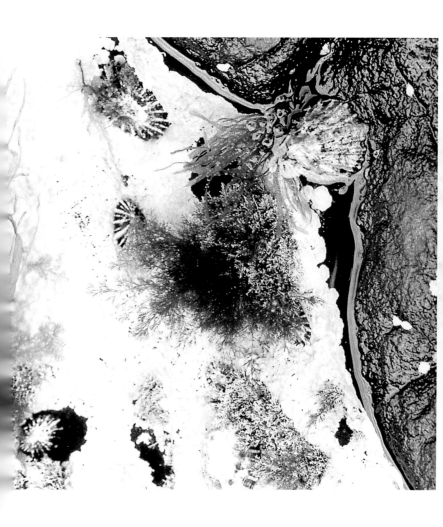

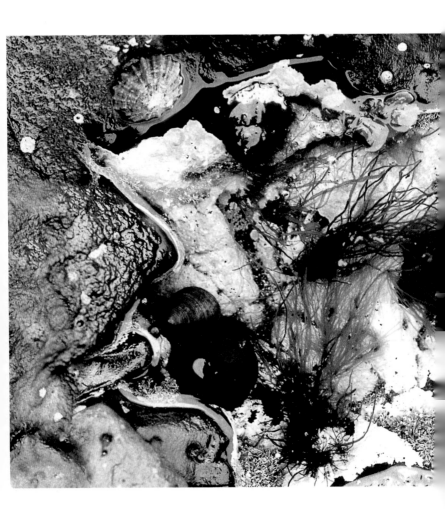

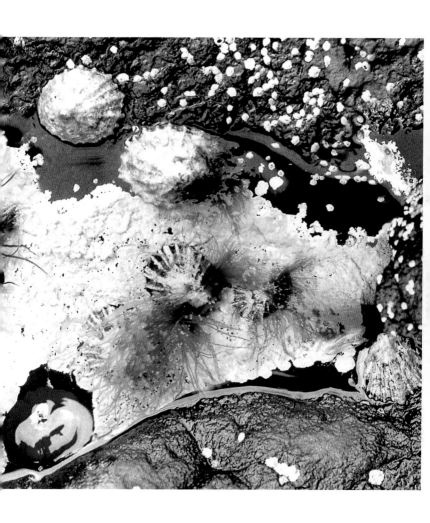

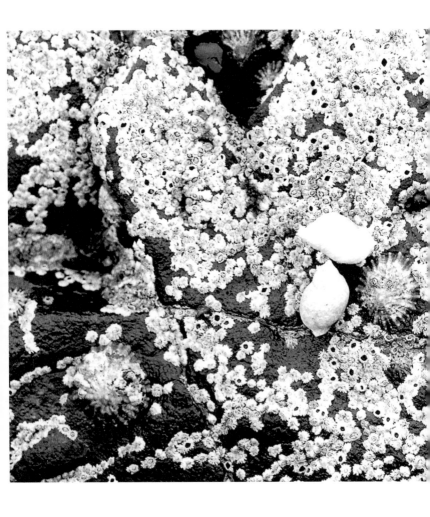

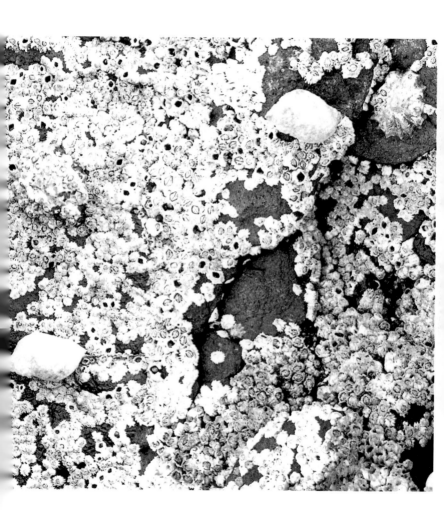

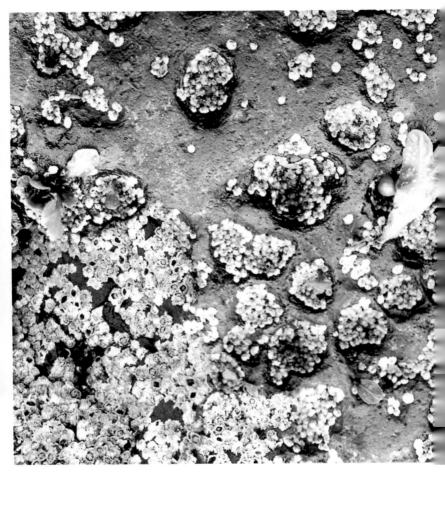

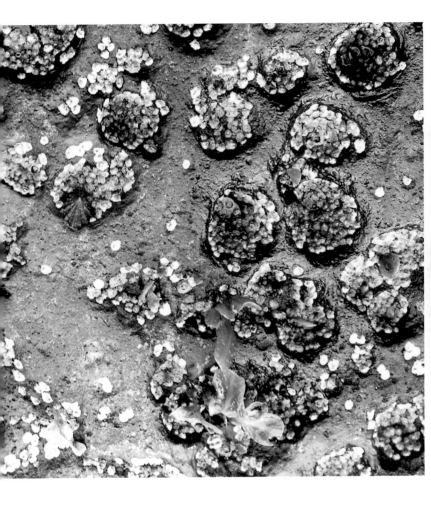

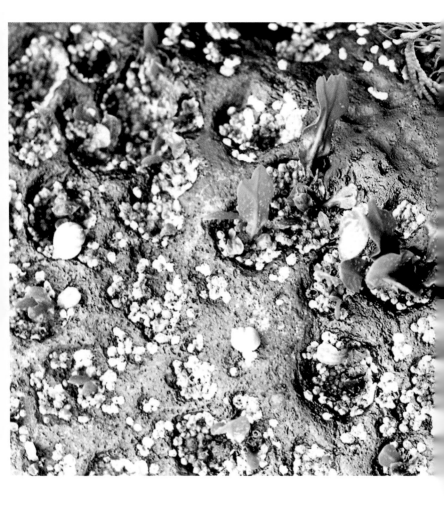

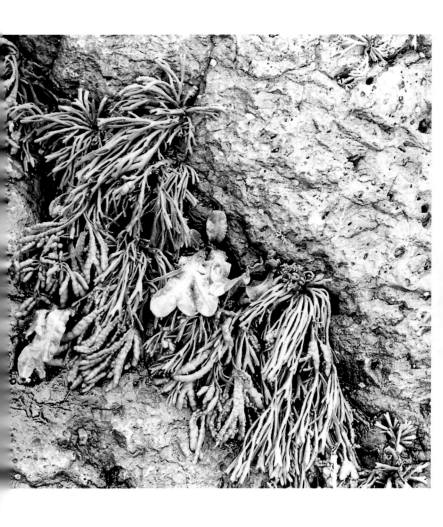

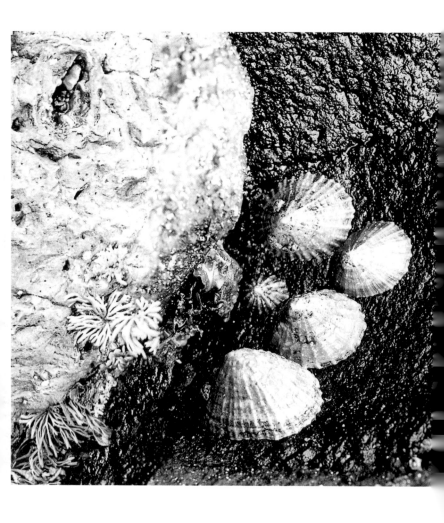

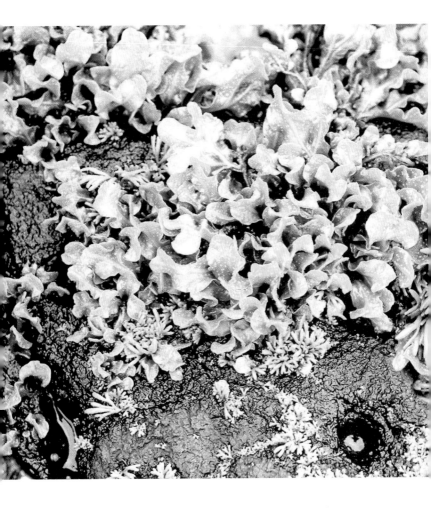

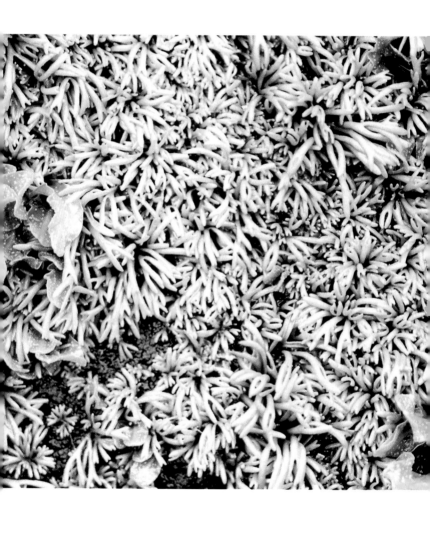

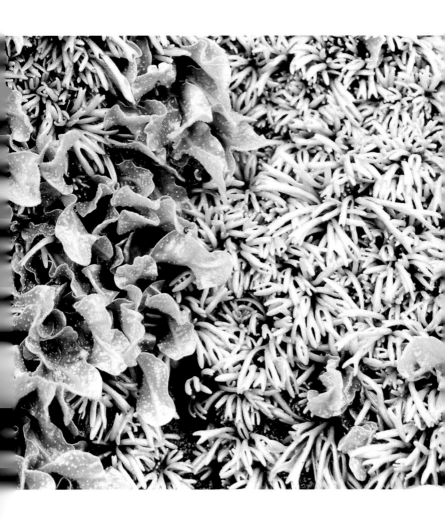

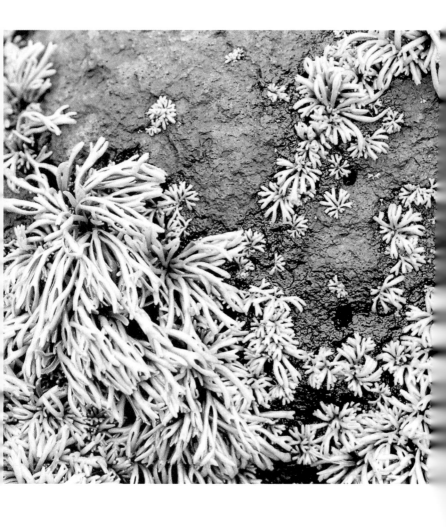

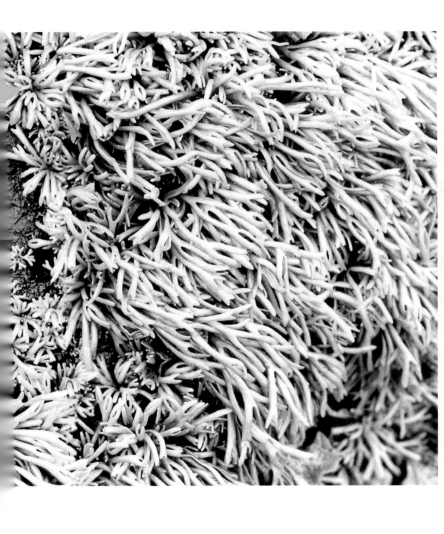

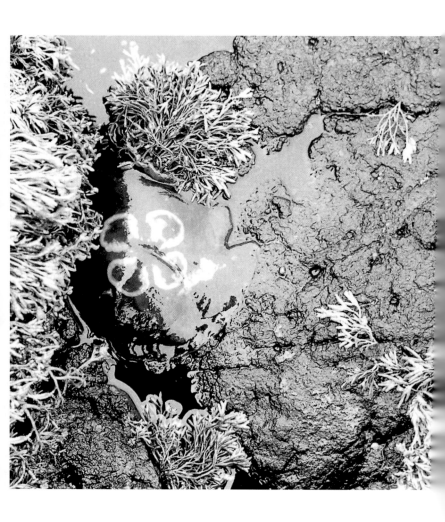

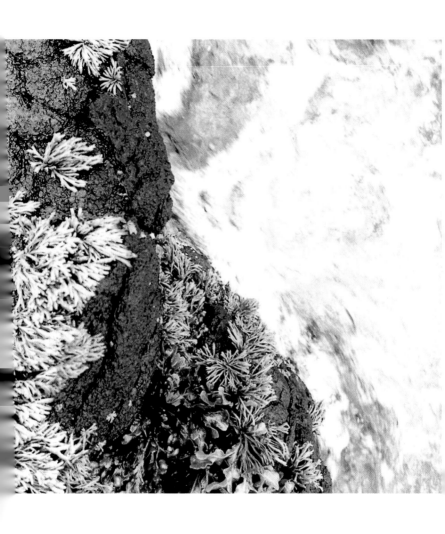

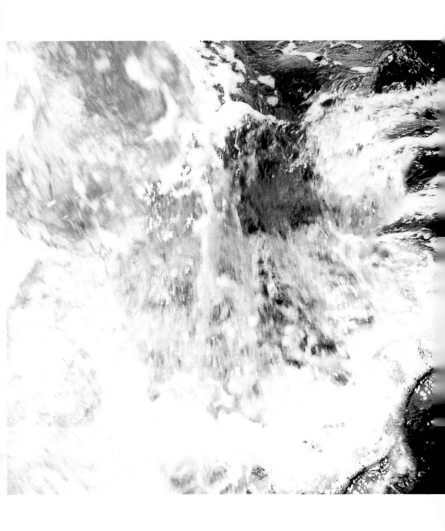

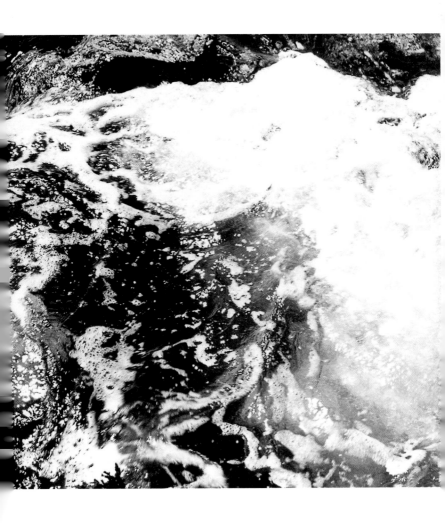

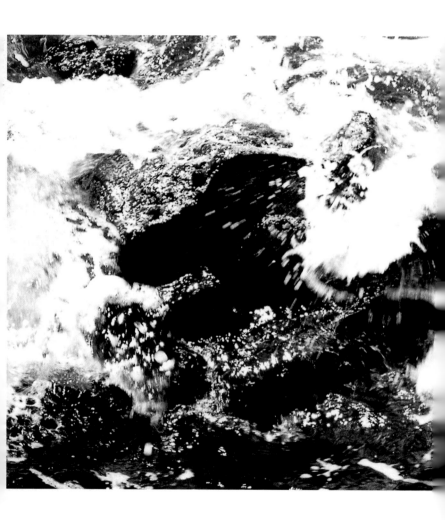

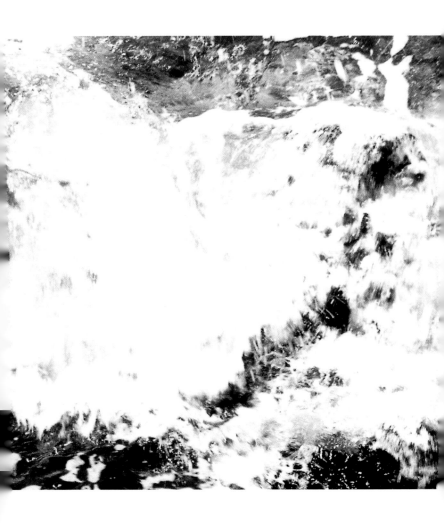

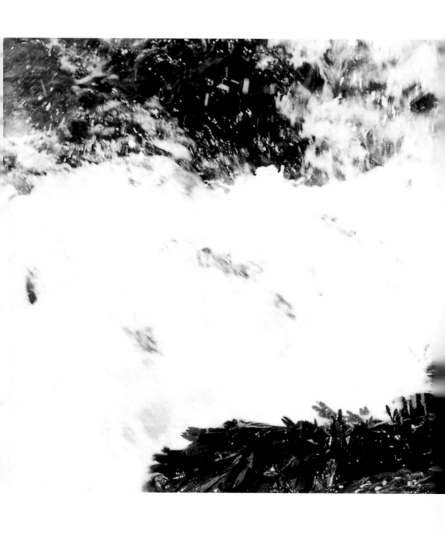

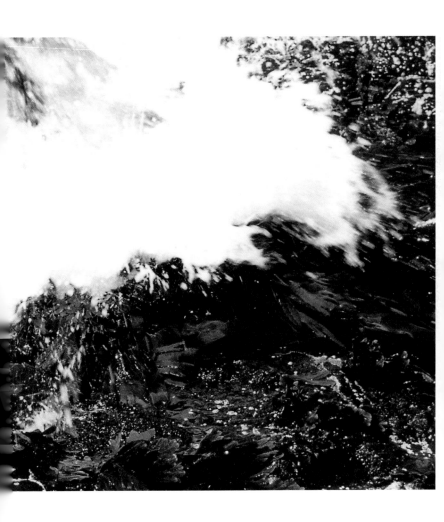

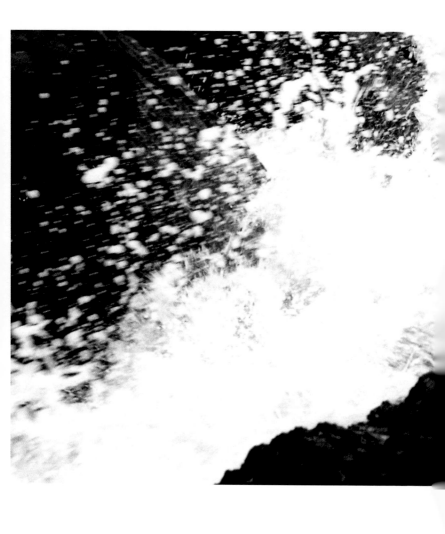

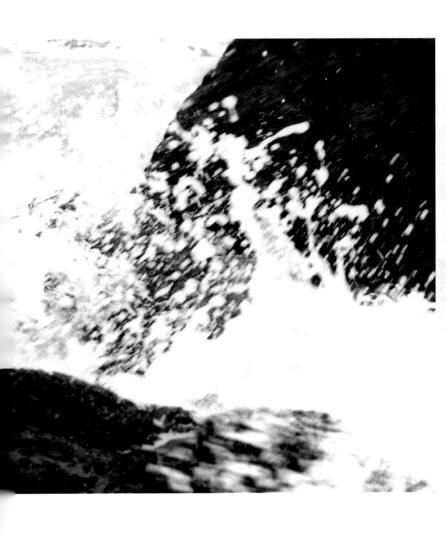

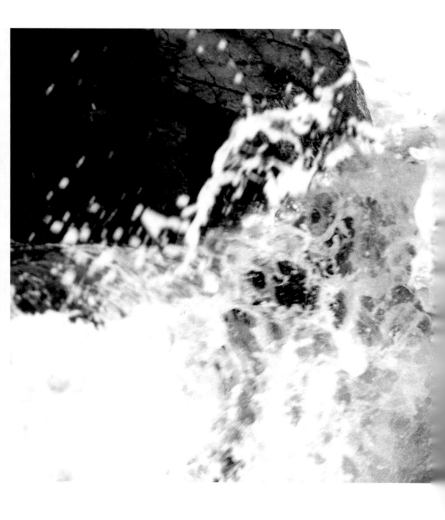

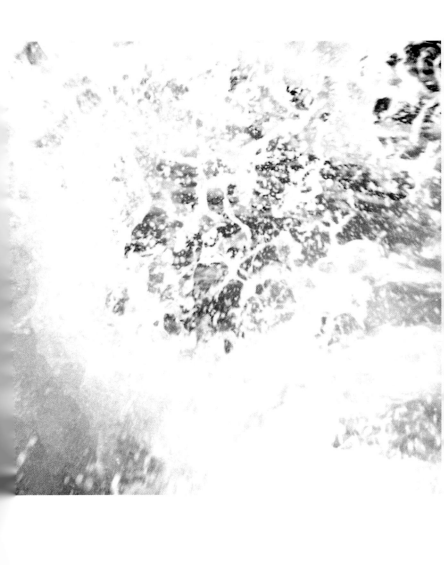

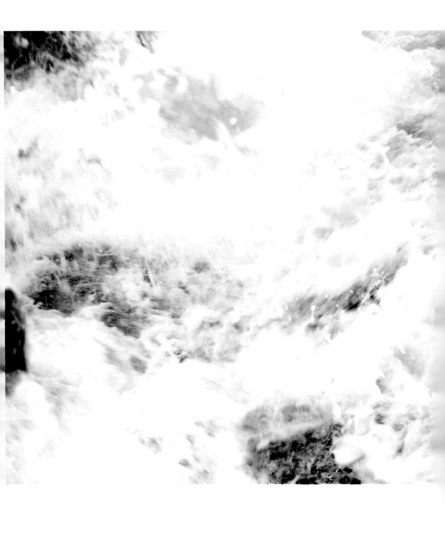

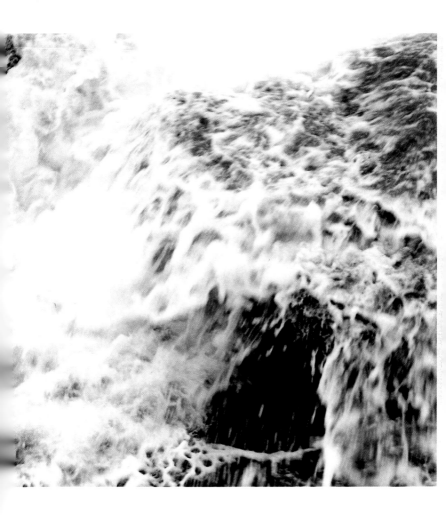

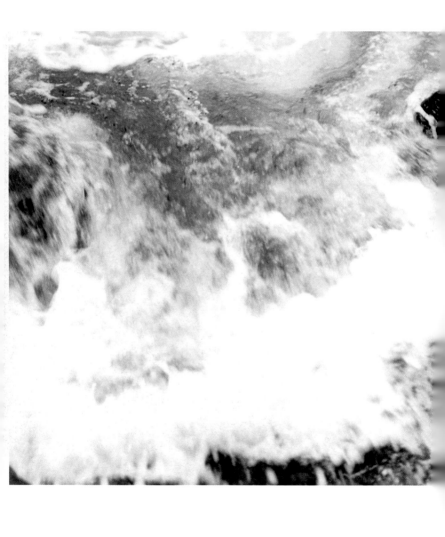

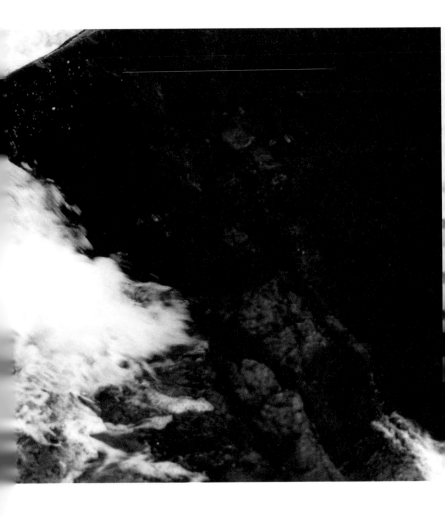

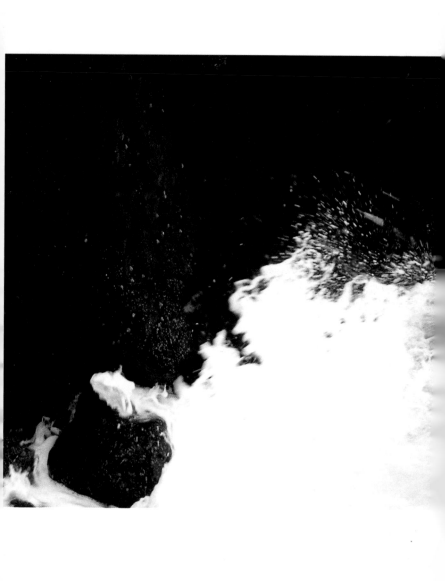

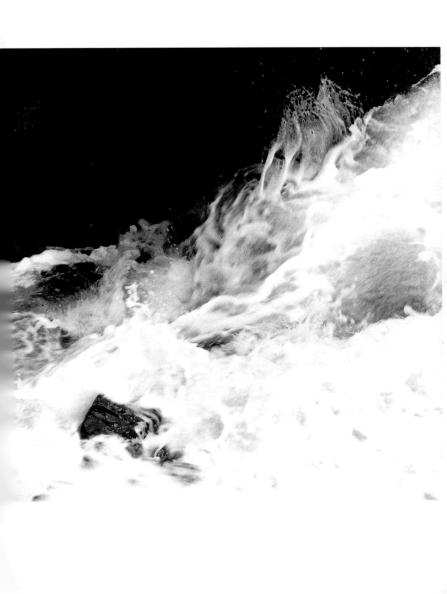

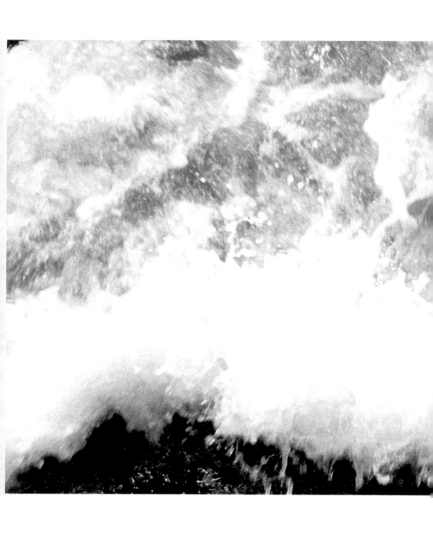

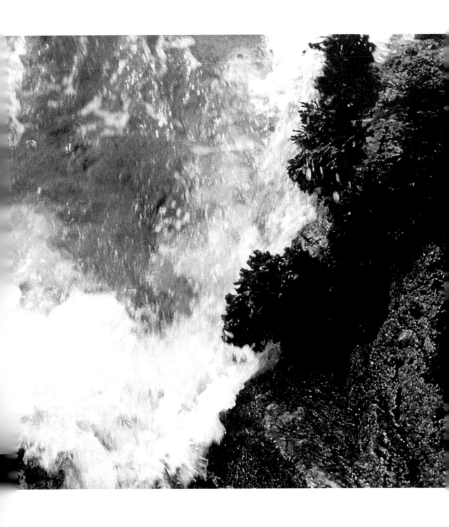

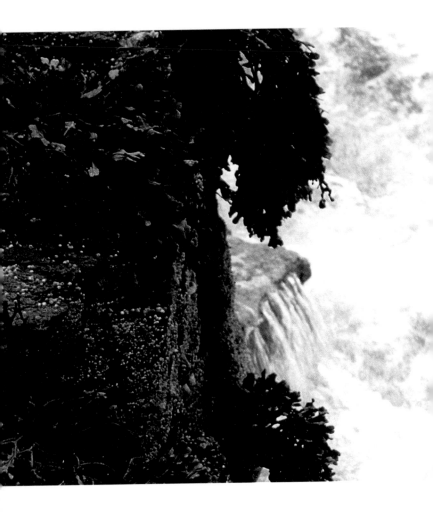

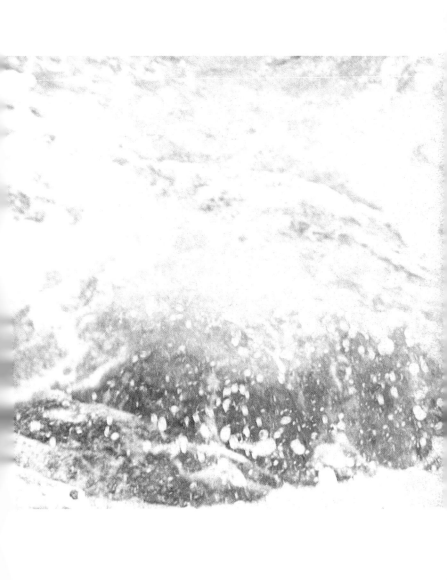

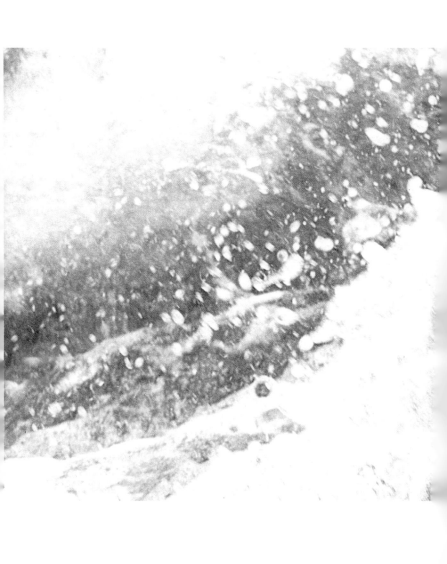

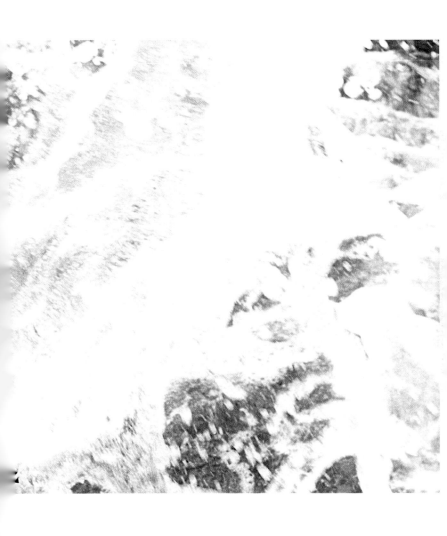

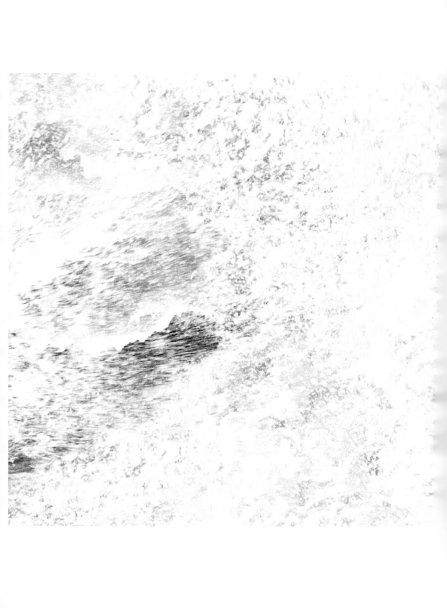

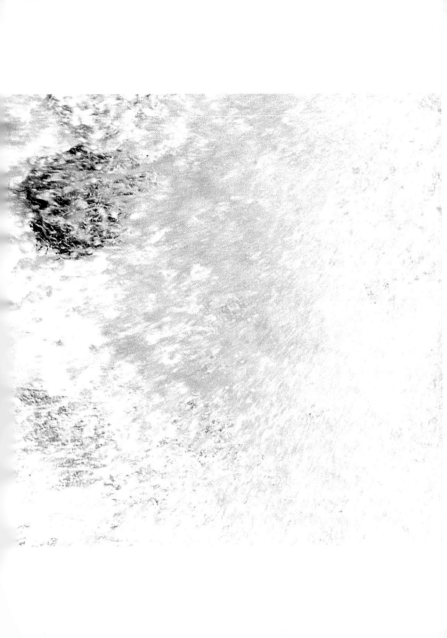

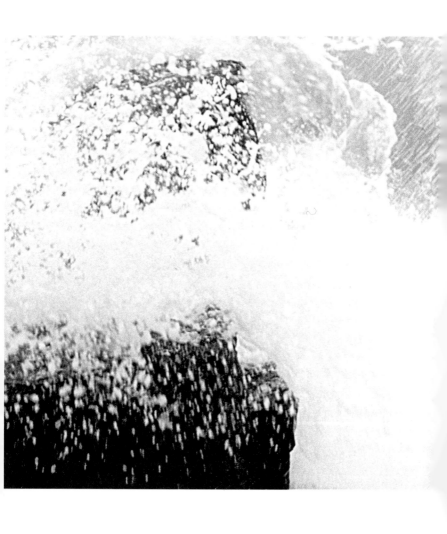

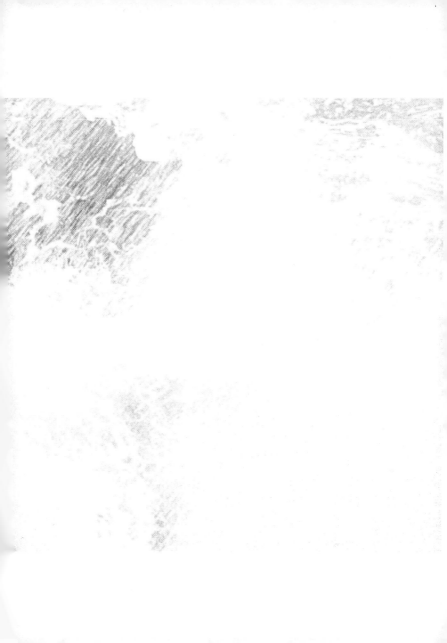

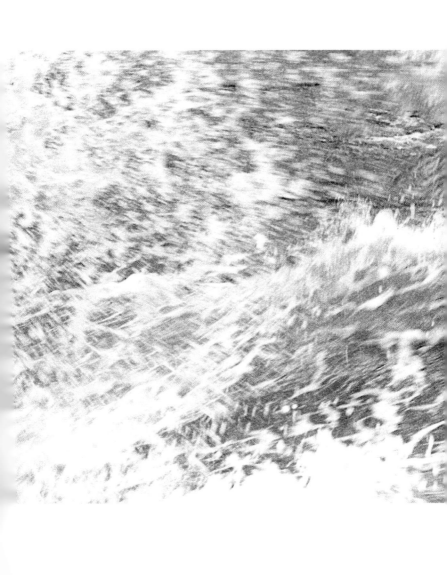

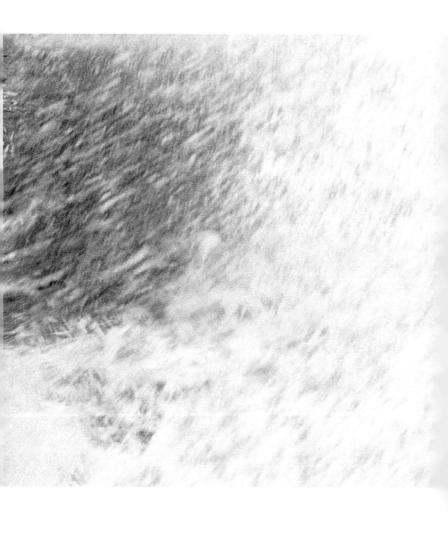

pocketbooks

Autumn 2001

11 MACKEREL & CREAMOLA
 A collection of Ian Stephen's short stories with recipe-poems
 and children's drawings, *Mackerel &Creamola* is a rich portrayal
 of contemporary life in the Hebrides, which draws on the author's
 deep knowledge of sea lore. With a foreword by Gerry Cambridge,
 recipes by Donald Urquhart, and an audio CD.
 ISBN 0 7486 6302 9 paperback, 208pp, £7.99 (including VAT)

12 THE LIBRARIES OF THOUGHT & IMAGINATION
 An anthology of books and bookshelves edited by Alec Finlay,
 gathering an imaginative selection of contemporary writing
 and artist projects inspired by books, bibliophilia and libraries.
 ISBN 0 7486 6300 2 paperback, 208pp, £7.99

13 UNRAVELLING THE RIPPLE
 A portrait of a Hebridean tideline by Helen Douglas, this
 beautiful visual book unfolds as a single photographic image
 flowing through the textures and rhythms of sand, wrack
 and wave. With an essay by Rebecca Solnit.
 ISBN 0 7486 6303 7 paperback, 208pp, £7.99

Spring 2002

Available through all good bookshops.

Book trade orders to:
Scottish Book Source, 137 Dundee Street, Edinburgh EH11 1BG.

Copies are also available from:
Morning Star Publications, Canongate Venture (5), New Street,
Edinburgh EH8 8BH.

Website: www.pbks.co.uk